Master

Posing Guide

FOR PORTRAIT PHOTOGRAPHERS

J. D. Wacker

AMHERST MEDIA, INC. ■ BUFFALO, NY

Published by:
Amherst Media, Inc.
P.O. Box 586
Buffalo, N.Y. 14226
Fax: 716-874-4508
www.AmherstMedia.com

Publisher: Craig Alesse
Senior Editor/Production Manager: Michelle Perkins
Assistant Editor: Paul E. Grant
Assistant Editor: Barbara A. Lynch-Johnt

ISBN: 1-58428-057-3
Library of Congress Card Catalog Number: 00 135909

Printed in Korea.
10 9 8 7 6 5 4 3 2

Notice of Disclaimer: The information contained in this book is based on the author's experience and opinions. The author and publisher will not be held liable for the use or misuse of the information in this book.

TABLE OF CONTENTS

PREFACE

"Everything is just beautiful, we love his portraits, but that's not his smile."

After a pre-portrait consultation and the portrait session we felt that we knew the subject and his personality fairly well. So, this statement really puzzled us. We'd think, "Did he steal the smile from someone on the way to the studio?" What did this really mean?

We would ask questions to try to define exactly what the problem was. Yet, the best answer we would get was, "That's just not his smile."

I set out to discover what it was that bothered these customers . . .

I'm sure many of the comments were from mothers who remembered their little Johnny's toothless smile from his first grade school portrait. Now Johnny is 6'4", 270 pounds, and is starting defensive end on the high school football team. Classmates refer to him as "Big John" and he takes pride in collecting paint from the helmets of opposing quarterbacks. Needless to say he's changed a little since the first grade.

Yet, there were many other cases where the reason wasn't quite as clear. So, determined, I set out to discover what it was that bothered some customers but was fine for other customers. After comparing the demographics of the different plaintiffs and getting nowhere fast, I found a reason that is the foundation of this book. As it turns out, it wasn't always specifically a problem with the smile, but a matter of the subject not looking comfortable and at ease with the portrait experience.

Since then, I've realized that a portrait session follows the 80/20 rule: 80% of the session is mental (verbal and nonverbal

communication between the photographer and client), while only 20% is technical (setting the lights, choosing a background, clicking the shutter, etc.). I've always subscribed to the notion that, as professional portrait photographers, we photograph what is in the heart, not just the external features of our subject.

This is a guide to posing. I use the term "posing" loosely, since I don't physically "pose" my subjects and it is not my goal to help you "pose" your subjects. Right now you're thinking, "Great, I bought a book on posing and already the author is saying it's not a book on posing." Never fear. There are plenty of images for you to study and use for your subjects. **This book goes beyond posing, into improving sales and optimizing your time.** There have been great posing guides published with page after page of examples of different poses, and they make great references. Unfortunately, sometimes when you try pose number 132-4: "Girl sitting on park bench with legs crossed and hands on top leg," with your subject, the result just isn't the same. Hopefully, the theory and practice found here will help you to try a few different poses, and see why they work well for a particular subject, or why they don't.

For the most part, the poses you'll find here could be considered "traditional" poses. Do not limit yourself to these poses. They are fundamental guidelines for you to experiment with and blend with your own originality and the individual personalities of your subjects. Being able to apply them to different individuals is part of what makes our job so dynamic and exciting. It would be impossible to record all possible "poses" since, as mentioned above, we photograph what's on the inside, and we're all different!

This book goes beyond posing, into improving sales and optimizing your time. The portrait studio cannot survive on artistry alone. Sound marketing and management techniques are essential to your success.

Here's our task: We need to pose or position our subjects so they don't look posed. We must capture what happens naturally and looks comfortable. This book is divided into three parts, which together form a system for you to apply with your subjects to make this task less difficult. Part one focuses on the psychology of posing, the gray area that can only be described as "that is (or isn't) his smile." Part two explores the mechanics of posing—the physical position of the body, limbs and features, following a simple rule of posing mechanics I learned from my father, "If it bends, bend it." Part three illustrates posing in practice in several different types of portraiture, from a baby portrait to large group photography.

Whether you are a longtime portrait photographer or a new student to the world of photography, I hope that in this book you feel my excitement and try to produce the finest portraits for your clients. I hope it helps you help others enjoy their portrait experience and make your photographic endeavors, either as a hobby or as a career, more fun and fulfilling.

INTRODUCTION

In the days before electronic strobes and "fast" film, portrait photographers were required to use a limited catalogue of poses. In fact, the subjects were clamped into position with braces, brackets, and more to hold them steady for the long duration of the exposure. No wonder they all have that same expression! That same expression that simply "wasn't their smile!"

Recently, the focus of many photographers' attention has been aimed at digital capture, retouching, enhancement, compositing, and manipulation. We don't think twice to buy the latest upgrade for our film scanner driver software, but bypass spending on books and videos on posing, exposing, composition, lighting and so on. We know *that* pretty well—and besides, who has time for anything else when we're reading our new version 13.0 photo-manipulation software manual?

> In the days before electronic strobes and "fast" film, portrait photographers were required to use a limited catalogue of poses.

With all the advancements in camera and lighting equipment, lenses, film and paper quality, and especially digital imaging, it is getting easier and easier to produce a quality photograph. Just dig through some old negative/transparency files and see all the over- and underexposed and out-of-focus images with missed expressions, etc. Now, if a situation manages to throw off your camera's all knowing virtual brain, you can either "fix" it with some tonal adjustment, or simply delete it on site and shoot it over! So, how is a professional photographer supposed to set him or herself apart from the "Uncle Joes" of the portrait industry? (The "Uncle Joes," by the way, own a multi-megapixel automatic digital image

capturing camera and a super gigahertz computer with industry-leading photo enhancement software and a couple thousand dpi photo-realistic inkjet printer that they bought off the web!)

Have you ever wondered why today's teens would ever consider wearing "those awful" bellbottoms you wore in college? It's not because they really look good. It's because they think they look cool, because they're unique. Today our challenge is much greater than back in the clamped-neck years. Competitive and societal pressures add to the challenge. Clients want variety and they want it in less than an hour! What strategy will set your studio apart from the rest? Be unique! Strive to make your subjects look their best, using a variety of posing, lighting, camera, and now digital techniques.

Quality portrait posing flatters the subject and makes him happy. Happy subjects buy portraits.

The restaurant industry felt the effects of convenience-minded marketing of fast-food chains long before the portraiture market. Yet, gourmet restaurants survive and even flourish. Why don't we just go where we get a meal faster and cheaper? Understanding image and perception of quality is the key. A statement on the back of a small town restaurant's menu made this issue quite clear, "Good food isn't cheap. Cheap food isn't good." Quality portrait posing flatters the subject and makes him happy. It has added value over "mug shot" style portraiture. Happy subjects buy portraits. Thus, we can continue making a living.

My father assembled marketing ideas passed down from my grandfather and great-grandfather. He summarized them in his MSQ formula:

Success of the Portrait Studio = Marketing + Service + Quality

Like tripod legs, if you remove one of these factors, the other two can't hold up your business for long.

Certainly, sound posing is but a single element of quality. But in this fast-paced world of pixels and intercontinental digital image transfer, sound posing is becoming unique, as are sound lighting techniques. This is unfortunate, but for you, the "guerrilla" in the portrait world, it is a niche to exploit. Study and learn. Know the *why* behind the quality portrait and your work will stand out from the rest. Posing is the key that separates professionals from amateurs. Have fun with the ever-changing technologies and trends. But, like a goose that temporarily leaves the flock, always return to quality fundamental techniques that have withstood the tests of time.

Psychology of Posing

CONFIDENCE

If posing is 80% mental and only 20% physical and if our camera captures the essence of the person or pet, think of how we must look at a portrait session. As a portrait artist, it is your responsibility to be in control of the portrait experience.

An ounce of confidence is the key ingredient we need to obtain control. A positive connection, or rapport, between you and your subject starts with your own confidence. If you're confident, he'll feel it and he'll relax knowing that he's made the right choice, choosing you as his photographer.

If our subject was a ball of clay, which could be easily molded into any position, or a robot guided by remote control, our job would be simple. But he's not. He has fears, misconceptions and doesn't know what to expect. Most people are naturally a bit nervous about having a portrait taken. If you

Sessions full of confidence and enthusiasm make our job fun and serve as a basis for return business.

do not attempt to show interest in your subject, his nervous energy will become more negative. It is easy for him to become bored, uneasy, even upset. These emotions will inevitably be portrayed in the final image, and you will hear those four words—"That's not his smile." Alternately, you can convert his nervous energy into enthusiasm by showing interest in him and in making a wonderful portrait for him. Sessions full of confidence and enthusiasm make our job fun and serve as a basis for return business.

When used in the proper amounts, self-confidence and energy are particularly important traits for portrait photographers. More than most professions, our personalities can be reflected clearly in our work, on the faces and overall posture of our subjects. Thus,

building good client rapport is certainly a worthwhile objective. Do you have to be a clinical psychologist to take someone's portrait? No, but if you don't get caught up in f-stops and watt-seconds, and realize the importance of the human factor, your effectiveness as a "poser" will grow. Don't be afraid to show your passion for photography. An organized game plan to encourage photographer/client interaction is the best way to boost the session confidence level and improve your portrait results.

Once, a young aspiring photographer named Yosuf Karsh presented his portfolio to Edward Steichen, a pioneer of photography as fine art. Steichen told Karsh the now famous story of having been asked whether success in photography was due to luck, a question to which he unhesitatingly replied, "Yes, it is—but have you noticed how that luck happens to the same photographers over and over again?"

A confident professional will present a complete experience during the portrait session and produce a quality product.

With time comes experience, and with experience comes flexibility and versatility. Like a professional fishing guide who needs to find hungry fish for his clients in even the worst possible conditions, you have to be able to make the best of a bad portrait situation. You must be ready and willing to try different "lures" if your favorite "can't miss" pose isn't working. A confident professional will present a complete experience during the portrait session and produce a quality product.

2

BASIC DOS AND DON'TS

● **PRIOR TO THE PORTRAIT SESSION**

Do your homework. We are human and we have limitations as to the number of ways that we can stand, sit, bend our arms and legs, and

> The better you understand the goals and physics of different poses, the more effective you will be . . .

so on. Chances are, most of the possible positions of the human body have already been drawn, painted, and photographed at one time or another. Certain artists made certain poses and lighting styles famous, but they didn't create them. It is up to you to study the work of other portrait artists and find poses that you like and feel that you can use in your own portraiture.

When you evaluate a pose, try to find out why you like it or don't like it. The better you understand the goals and physics of different poses, the more effective you will be at using them with different subjects in different situations.

Don't get locked in on one source. It's fine to have a mentor who you wish to learn from and to imitate, but don't limit yourself. There are all kinds of sources of ideas all around us, especially in our multimedia world. For example, if you plan to photograph teenagers, there are an overwhelming number of ideas available in magazines, videos, and even digital games. Look for a variety of styles and techniques.

Don't get caught up in trends. Overused trendy styles age quickly and may negatively affect your overall creativity and strengths. Trend style posing and portraiture can be fun and attractive to some clients, but keep your future goals in mind. Producing consistent high-quality portraits will help ensure your long-term success in the portraiture business.

Do practice poses yourself and with family members, friends, etc. A golden rule of posing is "If you can't do the pose yourself, how can expect to be able to explain or direct your subject to do it?"

Do watch other photographers pose subjects and what people around you do naturally. It is said that the best salespeople are good listeners. It could be said that the best photographers are good watchers. Take mental notes of natural poses and visualize how you can use them during a session. How another photographer poses a subject, or how someone stands naturally isn't always easy to imitate in your camera room. So, again, practice, practice, practice.

Do learn, practice, and use the rules and guidelines of posing, exposing, and composing for portraiture. These were established for a reason, and work well in many situations.

Don't think you can't break the rules and guidelines of posing, exposing, and composing for portraiture. Sometimes doing so will make the image unique and add to its impact.

Do take time to get to know your subject prior to his or her portrait session. A meeting or consultation prior to the portrait session is an effective tool available for building a sound photographer/client relationship. It will help you break the natural barriers between you and your subject, help your subject relax and ultimately help you capture good expressions.

This meeting is a vital information-gathering period where you have the opportunity to study the subject's natural poses and interests. Gather simple personal interest information that you can use to help relax him later during his portrait session. The best way to relax a scared senior boy or girl is to comment on his or her outstanding performance in last week's game or musical.

Don't think you can't break the rules and guidelines of posing, exposing, and composing for portraiture.

During the consultation, watch how the subjects carry themselves in a regular environment. Often these positions make for the best poses, because they are natural.

The consultation session allows you to learn more about what they want or expect from their session. Also, it is a good time to take care of big decisions that tend to weigh down a portrait session and ruin the mood and excitement. The type and number of outfits is one common such decision. If you wait until the portrait session to help them choose from their closet full of clothing, you may end up in the position of a bad guy for saying no to particular outfits or ideas.

A good consultation session will help educate the subject about what makes a quality portrait. Most of the time, the subject has no

idea, and it is your job to help him to make a good decision (help him, try not to tell him, unless he asks). An audio/visual program is an effective mechanism for consultations. You can create it to be complete, it can sell other products, it's always in a good mood (well, almost always) and is usually less expensive than hiring a new employee if your schedule doesn't allow you to handle all of these sessions yourself.

From the information you gather during the consultation, you should be able to formulate a rough outline of the images that you will try to create during the portrait session.

Do know your equipment, lighting and photographic techniques. You can't afford to be playing with your camera when you should be working with your subject. The more time you spend taking meter readings and moving lights, the more the subject will become uncomfortable and stiff. So again, spend time practicing with family members and friends. Elements such as lighting ratios, exposure and such must become second nature, so that your full attention can be devoted to the individual subject. Terry Deglau, formerly of Kodak, once mentioned that his father taught him to think of photography like dancing: it's so much to learn at first, but after you do it for a while, it becomes natural. This is not to say that you can't ever try anything new with a client, but experimentation is best saved for non-clients or after you have finished creating images requested and/or expected by a client.

> Experimentation is best saved for non-clients or after you have finished creating images requested and/or expected by a client.

● DURING THE PORTRAIT SESSION

Do try to maintain normal conversation. Silence can be deadly in a camera room. Your subjects will become self-conscious and more aware of their unusual environment if you don't speak to them normally.

Do be sensitive. Put yourself in your subjects' shoes. Understand that they may be scared or nervous. Remember that many of us love creating wonderful portraits, but hate being in front of the camera. If they are worried about a particular flaw in their appearance, remember these three steps:

1. Reassure them that their problem isn't serious.
2. Reassure them that you are aware of their concern, and that you, as a professional, will do whatever is necessary to minimize or eliminate the problem.
3. Reiterate a positive about their appearance, clothing, etc. to help them feel more at ease.

Do try to flatter the subject. This can be a challenge, because your flattery should be appropriate and in the right amounts. Too much flattery will appear phony and lose its effectiveness. Often expressing your own excitement about getting a good photograph is all it will take to reassure the subject. For instance saying, "Oh, that was great!" or "I'll be looking forward to seeing that image myself!" after taking an exposure will do, especially if it is sincere. Keep in mind that the actual portrait session is a big part of the whole portrait experience, and that the underlying goal of most portraits is to make the clients happy about themselves.

Do remember names. In the "heat of battle" it's easy to forget a subject's name. This isn't a critical error, but should be avoided. Remembering names can, however, be a powerful tool to help you gain and maintain control. For example, using the names of all the bridal party members, parents, etc. involved in a wedding during your posing will gain their attention, and cooperation, and earn their respect. It shows that you are professional and are serious about your business. Pointing and saying, "Hey, you move over there and you move down a step," isn't professional and won't set you apart from the rest of the paparazzi. With individuals, specifically children, using their name will make you less of an imposing stranger and help them relax. Don't forget to let them know your name. It will be less awkward and they won't have to call you "Mister or Miss Photographer."

Saying, "Oh, that was great!" or "I'll be looking forward to seeing that image myself!" after taking an exposure will help your client enjoy the session.

Do use some humor, if possible and appropriate. Of course, bad or off-color jokes can destroy more than just the portrait session. But a simple funny story or comment about the weather or your own camping misadventures can serve as a good icebreaker for a session. Humorous names for poses can also be useful, such as the "Heimlich," the "Pretzel," etc.

Don't use too much photographic slang that the subjects may not understand. Telling them you are going to SHOOT them, BLOW them up, FRAME them, and finally HANG them may not be what it takes to get them relaxed.

Do try to keep your posing fast and fresh. Once again, this is a skill that can only be developed from practice and experience. Working

quickly shows your excitement and this will rub off on your subject. She will feel better knowing that you are in control of the situation. Also, most of our subjects aren't professional models and they can't hold a pose or expression for very long—this is particularly true for two-year-olds and cats. Pets, specifically, get warm and bored rapidly, and often your first image is your best. Don't hesitate to "just shoot the picture." One frame of film won't ruin the session if it doesn't turn out. That's what garbage cans (and now erase buttons) were made for.

Do show the pose. Mimicking is a great method for posing. If you have the attention of the subject, she will almost automatically mimic you as you move and demonstrate a certain pose. It's easy and it's fast. Also, she is reassured by the fact that she can see that you are able to do the pose. Remember the mirror effect. Show the pose in the opposite left-to-right direction as you wish the subject to pose. Invariably, if you move your right hand and tell the subject to move her right hand, she will move her left hand, mimicking your motion.

> Working quickly shows your excitement and this will rub off on your subject . . .

At which point you tell her, "Your other right." This is a prime opportunity to combine posing methods: showing a pose and humor. A male photographer showing a feminine pose is almost always a great way to bring freshness into a session that has become stale and boring.

Don't touch the subject excessively. Common sense should prevail here. Respect your subject's space. Regardless of how well you think you know the subject, or how comfortable you are working with her, most subjects will freeze if you touch her because you are invading her comfort zone. Unless you're Yosuf Karsh, pulling a cigar out of the mouth of a person like Winston Churchill to get an expression may lead to a very short portrait session or possibly a change of your career.

If the subject just doesn't understand what you are trying to explain, and touching is unavoidable, *always* ask or at least explain what you are going to do before you touch the subject—even if it is just a slight placement of a hand or curl of hair. Using your fingertips to touch will help limit uneasiness. Often, a slight touch on the shoulder or hand with directive words will be all that will be necessary to help her move in the manner that you intend.

With children, try to find out which of their family member's or friend's touch they respond to best and have that person handle them. Some photographers naturally connect with children and have no problem getting close.

Don't keep your door shut. It varies from subject to subject, but consider allowing their friend or family member into your camera

room during the portrait session. Sometimes it will relax the subject, sometimes it won't. Usually, one or the other will say something if they are not comfortable with the other in the room.

Do be flexible. It can be difficult, but sometimes it's best to give up on a pose that just isn't working and move on to another. You may wish to just take the picture even though you don't feel right about it (remember your garbage can). Otherwise, the subject may feel insecure about not being able to do what you want him to.

Do be open to your subject's posing suggestions during the session. You may be pleasantly surprised by the new usable ideas that you may collect while trying his ideas. Doing so will make him feel more involved and important. Using his ideas and showing your excitement will make his level of confidence and excitement soar!

> . . . using the same pose too many times in the same session and with too many clients will limit your versatility . . .

Don't overuse a pose. Even if it is successful, using the same pose too many times in the same session and with too many clients will limit your versatility and drive away potential new clients. Also, the pose may not work for everyone. You must have a full arsenal of poses to choose from for each individual client and situation.

● **FOLLOWING THE PORTRAIT SESSION**

Do continue to practice, practice, practice. Learn from your experience in real sessions. If your favorite pose didn't work, don't give up on it. Try to find a reason why it didn't work and consider changes that may help next time.

Do keep a file of successful poses. Make simple photocopies of your favorites and toss them in a box. In no time at all you will have a valuable database to refer to for future sessions as well as for your next illustrated marketing piece.

Do be aware of the success of certain poses. You will find that poses that may not be your particular favorite may be your best seller! Again, analyze the pose and try to determine the basis for its success. Obviously, you should use this pose again, but also try to adapt it to different situations.

Do listen to feedback (positive and negative) about your poses. If you receive consistent comments about a certain hand pose, prop, etc., pay attention and don't take it personally if it is negative. You may have a great pose, but it may be ahead or behind what the current times require.

3

GOALS

It's time to get back to finding why you like some poses over others and why some work and some don't.

Certainly, it is possible to capture a great photograph of a person or animal and make a great portrait without structured posing. Many photographers have made a great living, specializing in candid-style photography, especially wedding photographers. But if you ask any honest professional candid photographer, she will tell you that her best images didn't just "happen." They were the result of experienced anticipation. The photographer had done his homework, studied the situation, and had a preconceived image in mind prior to the arrival of the subject(s). Thus, pulling the odds into his favor to get that special image. He had a goal, which he wished to achieve, although it may be camouflaged by the spontaneity of the event.

Posing goals can be categorized into three categories: compliment, correct, and convey.

Successful poses also have goals. Posing goals can be categorized into three categories: compliment, correct, and convey. These goals are introduced here and will be illustrated in the upcoming chapters.

Compliment. Under most circumstances, a quality portrait should make the subject look her absolute best possible.

Correct. Some poses are necessary to minimize the appearance of a certain flaw: a crooked nose, lazy eye, scar, etc.

Convey. Possibly the most elaborate goal of a pose is to convey some message, theme, or mood about the subject or her place in the image scene. First and foremost, a good pose will show the personality of the subject and record more than her physical attributes.

The inner feelings of the individual are naturally conveyed not only by her expression, but her overall posture. The placement of the eyes can control the mood of the entire portrait. A simple tip of the head and shoulders can imply masculinity or femininity.

A constant challenge in portraiture is determining whether the pose connotes masculinity or femininity and adjusting accordingly. Posing a male subject gracefully and flattering him or showing strength and rigidity in a female subject intentionally is not incorrect. But accidentally posing a male in a manner which portrays him as passive or accidentally posing a female in a manner which makes her appear as assertive and controlling are easy mistakes to make and may not please the client. In general, a lean toward the camera and lower camera angles (with the subject looking down to the camera) connote strength and power. A lean away from the camera and higher camera angles (with the subject looking up to the camera) imply passivity.

Don't let your own psychology of posing become client mind control tactics . . .

Occasionally, a pose may convey an activity-type theme: athletic, dance, dramatic, etc. Some poses may be ones that the average person may assume naturally and appear very comfortable in a portrait, while other poses may be more exotic. The pose of a model in a commercial image is designed to add interest to the product being sold.

● REVIEW: PART I

Of all the aspects of posing, building photographer and client confidence and setting goals for a particular pose may be the most difficult. Be careful; don't let your own psychology of posing become client mind control tactics. It is one thing to help and guide a client, but another to dictate and order him.

Be courteous at all times when working with your subject. Real courtesy is a combination of your attitudes, your phrases, and your behavior. Saying something nice in an insincere tone as you look away from someone is phony and not real courtesy.

Experience will help provide you with valuable information to refer to in various situations with different people, animals, locations, climates, etc. But finding the proper presentation style necessary for each individual situation will be a dynamic process.

Next, Part II will help you physically build a portrait with your subjects who you have mentally prepared for their portrait experience. You will find that once you have tried and tested a number of poses for the individual subject, posing couples or groups will assemble like a puzzle, with a few compositional guidelines.

The Mechanics of Posing

4

POSING FROM THE GROUND UP

The life of the portrait photographer would be perfect if two-year-olds never cried, dogs and horses always had their ears up, and everyone knew how to pose. Well realistically, if this were so, we'd be out of jobs because everyone could take their own portraits. So, we're lucky to have the challenge!

We can experiment and test different films, light sources, and filters until we achieve results we are satisfied with and standardize these elements in our camera room. But we can't standardize our subjects! We can have them dress in the same outfit, stand them in front of the same background, and illuminate them with the same lights, but it is impossible for the images to be the same. Every subject is different. It isn't fair to them to treat them the same and produce "cookie-cutter" images.

> If you have properly established a valid connection with your client . . . you're almost there.

We can't expect them to sit on our best posing stools for hours as we bend their arms, twist their hands, move their hair back, move their hair forward, turn their legs, and not allow them to blink as we study them inch by inch to find their "ultimate" poses. Even the master artists had the leeway to "fill in the blanks" while painting a portrait. Unfortunately, as we know, the camera simply doesn't lie.

If you have properly established a valid connection with your client, you're confident, the client is excited, you're almost there, but not quite. Now it's your job to make your camera tell a nice, attractive, but slightly untrue story. Following is a system based upon a few basic concepts and a method for arranging key posing points and posing lines that you can use for almost any subject, and still maintain the flexibility to make each image personalized.

Early in the portrait process, we need to determine what our subject's positive and negative attributes are. Some features are obviously attractive and some aren't. But some features may attempt to hide themselves until your film is processed and your prints are finished. So, during your pre-portrait consultation, or as you are greeting your subject, take mental notes of any certain features that should be exploited or hidden. Often, the customer may be self-conscious about a certain feature or defect and tell you, directly or indirectly, about her concern.

Artistically, the portrait photographer is limited by his camera's film plane. We start with a three-dimensional subject and finish with a two-dimensional piece of paper. Where'd the other dimension go? Of course, depth is compressed into the height and width dimensions. We must be aware of how the depth is compressed and whether or not it will flatter our subject or not. Remember the "camera adds weight" theory.

We must start to think like a camera and understand how to compensate/adjust for compression in order to enhance our subject's positive attributes and hide the negatives. You can use different camera angles and different focal length lenses. A low camera angle can make a subject appear abnormally tall, while a high camera angle can make a subject appear abnormally short. For example, if your subject is conscious of his weight, use a high camera angle (above his head) to make his body appear smaller, focusing attention on his eyes. Also, the high angle will force him to raise his head and stretch his neck slightly and reduce the appearance of extra chins. A wide-angle lens used close to the subject can make him appear very large, but when used at a distance, can make him appear very small. Fish-eye lenses distort all dimensions, so careful posing is necessary to compensate.

> We start with a three-dimensional subject and finish with a two-dimensional piece of paper. Where'd the other dimension go?

In most situations, a medium telephoto lens (approximately 90mm–105mm for 35mm format and 150mm–180mm for medium format) is accepted as a "portrait" lens. It will produce the most believable relative image size of a subject. The most accepted camera angles are: eye level for head and shoulders portraits, chest level for three-quarter length portraits, and waist or slightly above waist level for full length portraits. Certainly other levels can be used very effectively. The most important point to remember is to avoid using one camera angle for all purposes.

Proper use of lighting through control of highlight and shadow areas is possibly the best way to depict the third dimension, but it is subject to the effects of different camera angles and lenses.

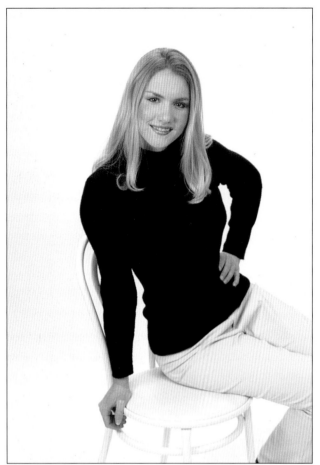 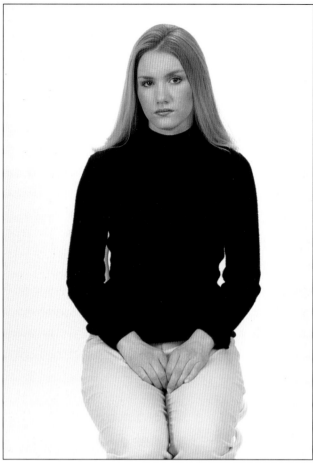

Structurally, we are limited to how we can bend, stretch, and twist our body. When you over-extend one of your legs, for example, to the point where you feel as if you are going to fall, your expression will inevitably change to one of fear. If our goal as portrait photographers is to make our clients look their best and avoid hearing, "That's not his smile," we must strive to position our clients in such a manner that is comfortable and balanced. If the client isn't comfortable, we need to determine if the pose is mentally or physically uncomfortable. Does it hurt, or does he just not like the pose? The following are some basic posing ideas which show how body mechanics, gravity, and posing interrelate:

Positioning. Positioning the subject includes the positioning of eight sections of the body that in and of themselves do not move. Jack Hamm, author of many terrific how-to drawing books, identified these sections as the head, neck, chest, waist, hips, thighs, legs, and feet.

Gravity Point. Specifically, effective posing is the positioning of these sections from the ground, or point where gravity has its greatest effect on the body, up to the eyes. The gravity point is usually the ground, but it may be different. If a subject is sitting, the gravity point is transferred from the ground to the seat of the chair.

Sitting on the edge of a chair (left), bench, etc., will always be more graceful than sitting square on it (right).

Gravity is our enemy! Join the plastic surgeons in the fight against the effects of gravity! First, identify the gravity point. Second, direct the subject (show the pose to her by doing it yourself) to stand or sit taller to pull her away from the source of gravity, thus decreasing the size of the gravity point. Muscles will be stretched and become more defined and attractive, and less of the subject will be compressed against the gravity point. Imagine if a balloon, harnessed to your subject's shoulders, was lifting her, and try to imitate the resulting position. Sitting at the edge of a chair, bench, etc. will always be more graceful than sitting square and flat on it. A great portraiture instructor, Len Levy, illustrated the difference by having a model sit normally, and then tell her to stand up and then to not sit so fast, but to sit half-fast.

Reducing the gravity point will naturally force the subject to shift their weight one way or another to achieve comfortable balance. Shifting the weight to one foot or buttock will continue to enhance the pose. A classic pose shifts weight to the back foot (away from the camera position) and aligns the other foot (the "camera foot" or "toe") lightly in front of it.

Posture. Good posture in a pose is recorded as good attitude in a portrait. Often, reducing the gravity point and shifting the weight will encourage good posture. Sometimes, added direction may be necessary to polish the pose with proper posture. Again, show the pose and provide a few directive words like, "Imagine an ice cube on the middle of your back." Try to accentuate muscle definition where possible. The subject can flex the muscle slightly or simply improve her posture by sitting or standing more erect. Do not over-pose to where the subject appears too straight and stiff. For some people who normally slouch, straightening up may be painful, and you may need to adjust or change the pose and/or your camera angle to compensate.

Good posture in a pose is recorded as good attitude in a portrait.

5

DIAGONALS, TRIANGLES AND BALANCE

Composition, as defined in Microsoft's Bookshelf CD-Rom dictionary, is "The combining of distinct parts or elements to form a whole and the manner in which such parts are combined or related." Simply it determines whether or not the final portrait is easy to look at. Arranging the distinct parts of the individual subject and the subject as a distinct part of a group is governed by the guidelines of compositional theory. The use of diagonals, triangles, and balance are three compositional elements that relate directly with posing.

The use of diagonals, triangles, and balance are compositional elements that relate directly with posing.

It is easy to make the mistake of posing the subject's head and eyes first, and then adjusting the remainder of the body and limbs to fit. This is backwards, for two reasons:

1. The subject will undoubtedly move his head and eyes when you have him move other parts.
2. The added time and adjustment will only come at the expense of losing the vital spontaneity of his expression. It could be said, "You only get one chance to get a good expression." Anyone who has attempted to recreate an expression that just happened naturally, knows it's true. You must work up to the expression in a fluid manner, not back and forth.

Understanding natural balance, weight distribution, and center of gravity is critical in posing. Pay close attention to the "bulk" or foundation areas of the body as well as the arms, legs, feet, etc. The

Top: Using the "Rule of Thirds" when posing will help create stronger compositions. Here, the subject's eyes are placed at the upper left intersection. **Bottom:** Positioning the body in an S-curve (left) creates a graceful feel, while a C-curve position (right) communicates a stronger message.

hips and shoulders are the two primary bulk areas and are interdependent. One goes up, the other goes down. Also, they are held together along a line that denotes an individual's own center of gravity. Jack Hamm found that a line running through the pit of the neck and drawn perpendicular to the floor shows where the feet must be placed in order for the pose to look comfortable.

Step back and view the pose as a whole and determine whether it is conveying the themes you intended compositionally. Use fundamentals such as the "Rule of Thirds" or "Dynamic Symmetry" by placing the most important element (usually the eyes) in the image in one of the four intersections created if you draw lines to divide the image into thirds vertically and horizontally. Perfect, even, centrally located symmetry is usually regarded as boring.

Think of the eight body sections mentioned earlier and decide whether they are arranged to form a graceful S-curve (or at least a zigzag, lightning bolt type pattern) or a strong C-curve. Watch for triangles and diagonal lines. In general, when the arms and legs are positioned in such a way that the basic outline of the subject's figure forms a triangle, as opposed to a rigid post or square, the pose will be more interesting. Triangular composition creates balance, which makes the subject(s) more relaxed and the resulting image more pleasing. The same idea applies to how individuals are arranged in a group. Be aware that equilateral triangles are more static than triangles with sides of different lengths. Static can be good to convey strength and unity: for a family, a team, or a graphic pose. For photographing groups, you can create diagonals and triangles by varying the heights of the individuals.

Arms and legs are often neglected and are crucial elements of a portrait compositionally. Not only can they enhance a portrait

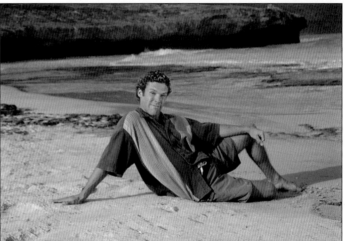

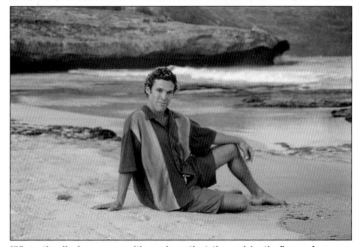

When the limbs are positioned so that the subject's figure forms a triangle, the pose will be more interesting. Triangular compositions create balance. Be careful to place the arms and legs in a comfortable position—not too close or overextended. Here, the bottom pose is the best.

Left: The shoulders should present a base for the head. **Right:** Photographing directly from the side may be acceptable in candids, but is usually unflattering in a more formal portrait.

by forming diagonals, but also they can also ruin a portrait if not handled carefully. Watch for mergers and amputations of arms and legs. Ignoring these distractions will make the two-dimensional image appear uncomfortable.

The head and shoulders should form some sort of triangle. The shoulders should present a base for the head. Photographing the subject directly from the side may be interesting in a candid or artistic image, but is usually unflattering in a portrait. The head becomes like a car teetering at an edge of a cliff, ready to fall at any moment. Often, when photographing a number of individuals one after the other and there is little or no time to meet with the subject, she will pose stiffly with her shoulders raised. Usually, just telling her to relax her shoulder(s) will solve the problem.

> The head becomes like a car teetering at an edge of a cliff, ready to fall at any moment.

Examine the subject's body structure to determine her natural balance and what poses will work better than others. People have different length upper torsos in relation to their lower torsos, and

accordingly certain posing techniques are more effective than others. For example, a person with a short upper torso may look hunched-over when sitting, but look great standing. So, don't get locked into a posing stool for your head and shoulders portraits.

Again, remember the rules of composition are guidelines that will help you create successful images most of the time. But be ready to break the rules when the right opportunity presents itself. Just as a tilt of the camera can make straight lines into diagonals, an unbalanced pose can create motion.

Be ready to break the rules when the right opportunity presents itself.

KEY POSING POINTS

Three particular body parts deserve special attention and consideration as to how their position affects the overall pose. They are the feet, the hands, and the eyes (in order from the ground up). Each has the power to transmit mood and expression to the camera and onto the portrait. Also, if positioned improperly, each can be distracting and detrimental to the portrait.

● FEET

Rarely are the feet the center of attention in a portrait, except possibly in an advertisement for shoes or foot medication. But they are critical to the portrait as a whole. A flat foot is not usually interesting to look at. When the subject is standing flat-footed, the gravity point is enlarged and the remainder of the body will appear flat. A foot with weight placed on the toes and with the heels raised is more dramatic, the gravity point is minimized and the body's pos-

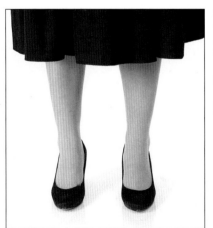 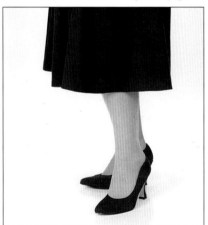 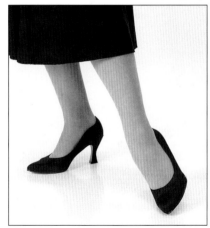

Left: A flat foot is not interesting to look at. **Center:** Placing the weight on the toes and raising the heels creates a more dramatic look. **Right:** Creating a diagonal line by pointing the toe creates a very graceful appearance.

ture will improve. A foot placed perpendicular to the camera's angle of view will appear abnormally large and be distracting and clumsy. A foot aimed directly at the camera will appear slim, which may not provide adequate foundation for the body. A foot placed between perpendicular and direct will form a diagonal line and appear more graceful and pleasing.

● HANDS

Do not ignore the hands in a portrait! The hands themselves are capable of telling stories and are a means of communication for the deaf. They can easily make a statement in a portrait. Many great portraits were successful because of the hold, grip, texture, gesture, or touch of a hand. You must be careful that what the hands tell about the subject's mood or attitude is congruent with your goal of the portrait and aren't contradictory to the subject's facial expression and posture. The hand is a combination of the palm, wrist, and fingers.

Unless it is your intention to use the hands to convey a message in the portrait, it is best to put the hands into a neutral, non-expressive position. You may even want to hide them.

Especially for women, but for men as well, protruding knuckles and veins on the back of the hand, or the puffiness of the palm are not as appealing as the lines and curves of the edge or side of the hand.

Left and Center: Protruding knuckles are not appealing in hand posing. **Right:** Placing too much weight on the hand distorts the shape of the subject's face.

When appropriate, elongate a woman's fingers to accentuate their grace and beauty. A classic hand pose for the woman brings together the thumb and middle finger, extends the index finger, while relaxing the other fingers and is a good choice when holding a flower. Another effective technique is to bend the wrist slightly,

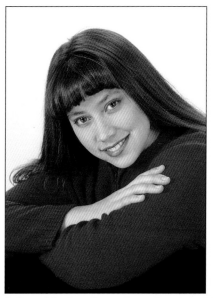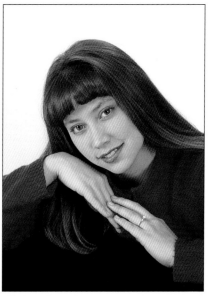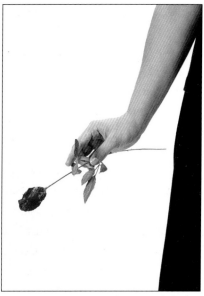

Left and Center: Elongating a female subject's hand creates a graceful appearance. **Right:** This classic pose is a good choice when holding a flower.

Left: The "dead fish pose" is never attractive. **Center and Right:** By bending the wrist down, you can make the hand look much more appealing.

so the back of the hand bends outward, rather than allowing the hand to hang lifeless (a.k.a. "the dead fish pose").

It is acceptable for the man's hand to close. Do not allow the hand to become a tight fist that will make the knuckles protrude further and unnecessarily add tension to the portrait. Tell the male subject to imagine holding a golf pencil (a pencil about three inches long) inside his hand. Also, it is acceptable to have the man hold something for the portrait (glasses, a newspaper, etc.).

Avoid placing the entire hand into a pocket, especially a tight pocket. The finger bones will show through the fabric in an undesirable skeleton-like fashion. Either place the thumb in the pocket, leaving the other fingers out and relaxed, or vice versa.

● EYES

The eyes are the key to every portrait, even if they aren't visible. A photograph of a person's external appearance is just a picture. A portrait is a graphical representation of a person's soul. The eyes, of

course, are the windows to her soul. They transmit the thoughts behind expressions. The precise angle at which a subject's eyes look in relation to your camera position, and reflect your light source(s) will determine the effectiveness of the portrait in capturing the essence of the individual.

Illuminating your subject's eyes is truly a life or death issue. Remember our first goal of posing, to complement. We wish to make our subject look her best. In photographic portrait competition, a phrase heard over and over is "there's no life in the eyes, they're dead." If, for example, the primary light source is above the subject, shadows are cast from the brow and across the eye, causing the whites and color of the eye to become dull and flat. This problem can cause the attitude of the portrait to change from positive/fun to almost negative/bored. Adding "life" to eyes can be as simple as turning your subject's head slightly toward the light source. Sometimes an additional strobe and/or reflector must be added. Particularly when working outdoors, you must pay close attention to the direction of your primary light source and pose your subject accordingly. Observe the effects of the light source on the subject's eyes.

Enhancing the elements of the eyes improves the appearance of the eyes as a whole. The iris (color) of the eye and the white of the eye are the most attractive.

The iris' apparent size is inversely affected by the pupil's (dark center) size. Since the pupil expands and contracts to adjust to the lighting conditions, control of the light intensity is essential. In low light, the pupil's size increases, thus decreasing the amount of the iris that is visible. So, use relatively bright light sources (modeling lamps, reflectors, etc.) to minimize the pupil and maximize the eye color. In the studio, positioning your main light source at a 45° angle to the side of the subject's eyes and above your subject's head will position the highlight in either the 11 or 1 o'clock position on the eye, and a beautiful crescent glow in either the 5 or 7 o'clock positions. This glow radiates color and life in the eyes.

Top: Avoid showing too much of the white of the eyes. **Bottom:** Also avoid low camera angles, which may make the eyes look uneven and distorted.

How you control the amount of the white of the eye that is visible will depend upon the individual and the mood you wish to convey in the portrait. Tipping the head downward and using a camera angle above the subject's head will maximize the amount of the white of the eye shown. The eyes will become very glamorous and seductive. This type of pose is typically considered feminine, and tends to be used only when photographing women and children. Avoid showing too much white and low camera angles, which may make the eyes look uneven and distorted.

Classic posing rules require the eyes to follow the direction of the nose.

Classic posing rules require the eyes to follow the direction of the nose. Contemporary posing styles break this rule often. When the eyes follow the nose, the portrait is graceful and pleasing. When they don't the portrait becomes more dynamic, but may look unbalanced and uncomfortable. Eye shape and size will determine what will look best.

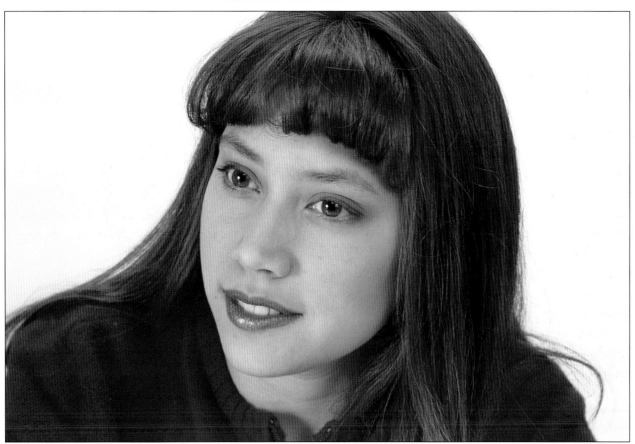

Although contemporary posing styles often break this guideline, classic posing rules require the eyes to follow the direction of the nose.

KEY POSING LINES

As we all know, if you directly connect two points you have a straight line. Since we are built symmetrically from a centerline, we have a number of pairs of body parts that are basically equal. A simple connecting the dots type exercise is possibly the easiest way to learn the difference between static and dynamic posing and quickly improve your portraiture.

● **POSING LINE EXERCISE**

Start with a standing subject without props or furniture. Simply visualize lines connecting the following pairs of body parts: feet, knees, hips, hands, shoulders, and eyes/ears. Do this from your camera viewpoint as well as from above the subject. Finally, determine whether these lines are flat, horizontal lines or if they are diagonals. Again, good compositional guidelines tell us that diagonal lines are dynamic and horizontal lines are not. It's that easy!

Notice that, without extreme bending and stretching, the knees' line is inversely related to the hips' line (one goes up, the other goes down). The hips' line is directly related to the shoulders' line, and the eyes/ears' line can vary greatly from the other lines as the head can pivot almost completely from side to side without moving the other lines.

The main difference between masculine and feminine posing is the relationship between the eyes/ears' line and the shoulders line. If the two

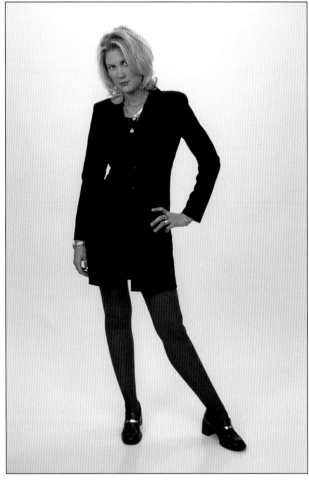

Begin this exercise with a standing subject without props or furniture. Visualize lines connecting pairs of body parts.

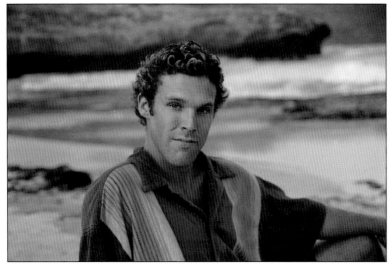

lines are parallel (head is tipped down to the lower shoulder) the pose is considered masculine. If the two lines converge (head is tipped up to the higher shoulder) the pose is feminine.

Now, experiment with the pose by identifying static lines and adjusting the pose to make them diagonal. Watch how the mood of the pose changes. Watch how the muscles become more defined and the slimming effect on the body.

Static lines aren't always bad. Big John, the huge football player, will look even more intimidating in his football portrait if you position him with all lines (the shoulders' line especially) horizontally. He'll resemble a massive immovable block of stone, the worst nightmare of opposing teams. But, most of the time, bigger isn't better in portraiture. So, John is the exception. But we won't tell him.

The exercise becomes more complex as you have the subject sit or lay, but the theory still works. When sitting or laying, twisting the hips or shoulders to make diagonal lines can create outstanding poses out of acceptable poses.

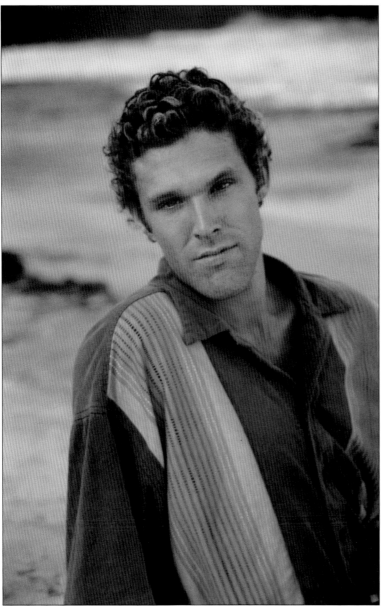

If the head is tipped down to the lower shoulder (top) the pose is considered masculine. If the head is tipped up to the higher shoulder (bottom) the pose is feminine.

8

KEY POSING PLANES

A group of straight lines on a common surface form a plane. In portraiture, there are three planes to consider: the head/facial plane, the body plane, and the film plane. In posing, it is the head/facial plane and the relationship of the head/facial and body plane to each other and to your camera's film plane that are the most relevant.

● THE HEAD/FACIAL PLANE

Imagine replacing the subject's head with a stop sign connected to the shoulders by the neck. The sign is a plane that can be tilted side to side, forward and back, rotated side to side, and a twisting combination of the previous movements. In general, it's always best to move the head in a twisting fashion to produce the most relaxed appearance. Turning the head/facial plane away from the body plane angle is more appealing than facing them in the same direction. Examples of good facial plane angles appear at the top of the next page.

The relationship between the head/facial plane and the body plane is important for successful posing.

Careful study of the subject's facial shape and contours protruding from the facial plane is vital. Your lighting and posing techniques must vary accordingly.

Above: Turning the facial plane away from the body plane angle is more appealing than facing them in the same direction.

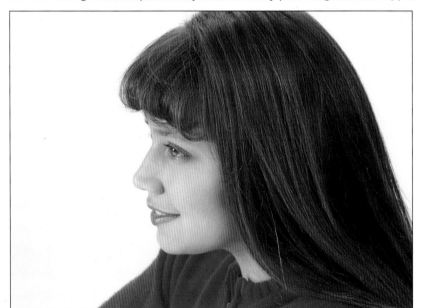

Turning the facial plane perpendicular to the camera plane results in a profile (left). Avoid split profiles, where the nose breaks the cheekline and the eye and brow are severed (right).

Turning the facial plane perpendicular to the camera plane results in a profile. Profile portraits are best reserved for subjects with even proportional facial features. Avoid split profiles, where the nose breaks the cheekline and the eye and brow are severed.

The three basic facial shapes are egg shaped, round, and narrow. The angle of the primary light source in relation to the angle of the facial plane is most important with round and narrow faced subjects.

Assuming the subject is facing the camera, a light source originating from the side of a round faced subject and camera will illuminate a portion of the facial plane, while casting shadow upon the remainder, creating the illusion of a smaller face. A light source

located from the camera angle toward a narrow faced subject will illuminate the entire face, making it appear larger.

In between the round and narrow is the average egg shaped facial shape. With the exception of the individual with classic high cheekbones, large eyes, a deep "Cupid's Bow" or "Angel's Touch" (the notch between the nose and mouth), and symmetrical features, most subjects do not look their best facing the camera directly (the facial and camera film planes being parallel) with the light source located at the camera angle. Turning the facial plane away from the camera slightly and changing the relationship between the facial plane and the angle of the light source will add depth to the contours of the face and make it more prominent and interesting.

As with the face, placing the body plane at an angle produces a more flattering effect (facing page) than positioning it parallel to the film plane (below).

● THE BODY PLANE

Control of the body plane is primarily concerned with the upper torso area. You may find it helpful in visualizing the body plane to think of you subject as wearing a sandwich board.

Good posture is the most important issue in regards to the body plane. A straight spine is essential for this plane to be used effectively. Even when the subject is leaning, the spine should be extended to avoid a slouch. For various reasons, some people may not be able to achieve perfect posture and care should be exercised to avoid unnecessary injury and discomfort due to posing. Rather than telling the subject to sit up straight, not slouch—which may annoy him—try telling him to "Imagine an ice cube running down your back."

As with the facial plane, turning the body plane away from parallel to the camera's film plane and lighting from the side will produce a more slimming effect to the bulk areas of the body and will enhance its curves. Again, turning the body totally perpendicular to the film plane will

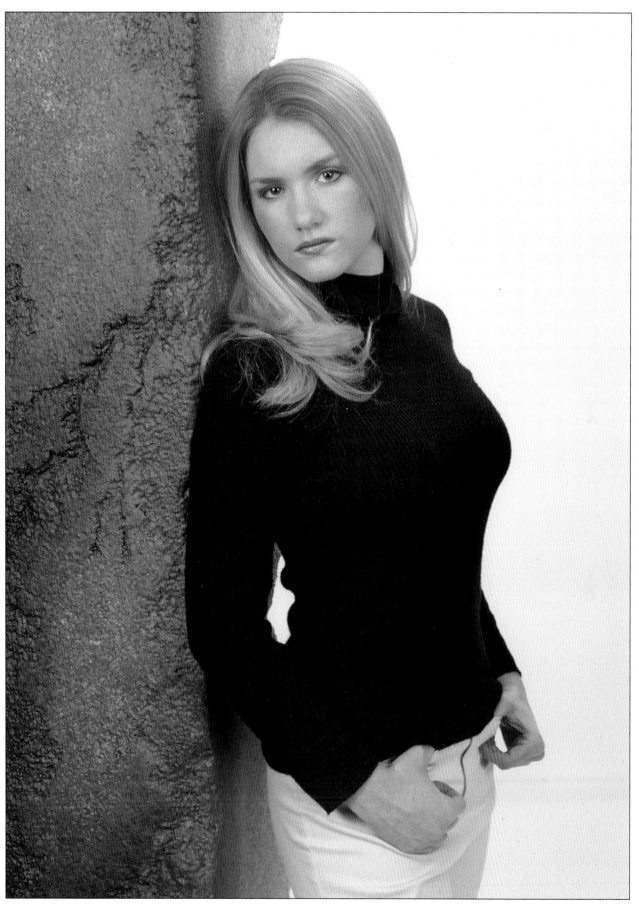

result in a body profile, which is best reserved for well-proportioned subjects.

Turning the body plane away from the primary light source will help to maximize body definition and detail in clothing. A bride's dress with intricate beadwork and lace is a perfect application of this technique. If you face the bride's body plane toward the light source, you risk "washing-out" or flattening the important detail of her dress. The same theory can be applied when positioning a pet to maximize the detail of its soft fur.

Turning the body plane away from the primary light source will help to maximize body definition . . .

CORRECTIVE POSING

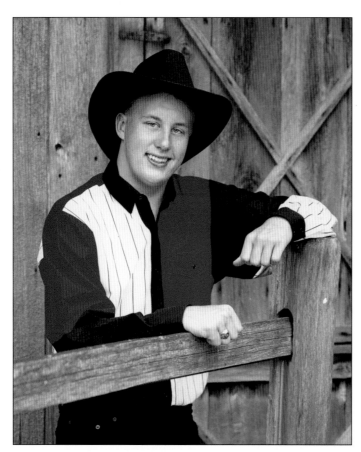

Using a perpendicular dividing element helps to create a slimmer appearance, in this case, of the subject's waist.

If our goal is to flatter our subjects, then all posing techniques may be considered as corrective. Some issues deserve more detailed discussion.

● **WEIGHT**

Creating illusions through controlled camera perspective, relative to the pose of your subject, is the key to controlling the appearance of weight in portraiture.

The "Divide and Conquer" illusion uses lines and planes perpendicular to areas of the body with excess weight. When viewing an area as a whole, we mentally estimate the area as larger than if it is divided into two or more parts. The subject's arms, and various props, chairs, and sets can serve as valuable division tools.

Accurate management of light traps also serves as a useful illusion. Arms left close to the body can create the illusion of added weight. This can be good if the subject is abnormally thin. But usually it is best to reposition the arms to provide a visual separation between them and the body. Light traps between individuals in a group can have the same effect. But if the traps become too large or are in too much contrast to the subjects, they will become distracting and possibly improperly divide the group.

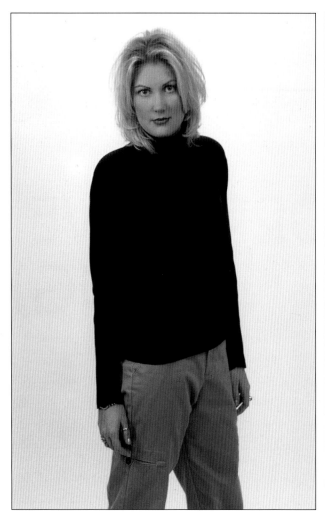 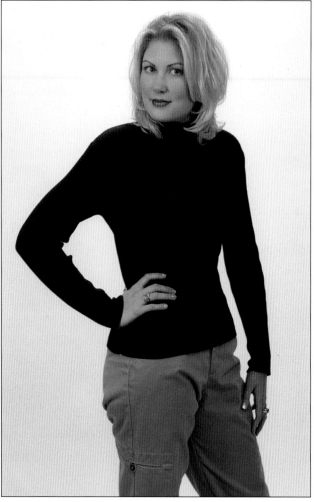

Left: Close to the body, arms can create the illusion of added weight. **Right:** It is usually best to provide a visual separation between the arms and the body. This image could have been improved further by relaxing the shoulders.

Often, it is necessary to exaggerate poses aimed to fight gravity and limit gravity points. Added stretches, twists and turns can make a great difference. For example, if the subject is concerned about having a double chin, have him stretch his neck toward the camera, or "play turtle." Bending the leg nearest to the camera and twisting the hips more than normal will add a dynamic flair to the portrait *and* help to create the illusion of slimness.

● SPECIFIC INDIVIDUAL FEATURES

Each person is different, and we all have our own attributes that we may perceive as positive and some not so positive. For the not so positive, you need to be particularly analytical and have a systematic plan of attack. Posing alone is usually not enough to completely eliminate the view of an unwanted element. A perfect pose can be ineffective if improperly illuminated. As a general rule, do not light a problem area to draw attention to it, but to hide it.

The Lazy Eye. Photograph into a lazy eye in order to make it appear larger. Avoid lighting the lazy eye from severe angles, which will create strong shadows across the eyeball, making the problem worse.

The Blinker. Most serious blinkers are very conscious of their condition, which adds to the challenge. Make an extra effort to relax the subject. Timing is important. Try shooting after a blink or when the subject doesn't expect it. Sometimes, a camera with a loud flipping mirror prior to the shutter's movement will cause blinks. Locking up the mirror prior to exposure can help.

The Squinter. Often, squinted eyes accompany a healthy smile. The connections and interrelated movement of the facial muscles cause this. One goes up, the other goes up. Telling the subject to open or "pop" her eyes just prior to evoking a smile can work as

Squinted eyes (as below) often accompany a healthy smile. Telling the subject to open or "pop" her eyes just prior to evoking a smile can help.

a compromise. Using softer, happy expressions can prove to be beneficial.

Noses. Simply put, large noses and profiles don't mix. Don't photograph a crooked nose directly or "head-on," but into the bend. A low camera angle will shorten a long nose, and a high camera angle will lengthen a short nose (long and short necks can be treated in the same manner).

Don't photograph a crooked nose directly or "head-on," but into the bend.

Bald Heads. Avoid high camera angles and hairlights when trying to minimize the appearance of a bald head.

Protruding Bones. Watch for protruding collarbones, Adam's apples, and wrinkled foreheads. Usually, the subject can remove or lessen them by moving slightly or physically relaxing the area.

Big and Small. Very few of us are perfectly proportioned. Some have large heads, big feet, and vice versa. Again, camera angle is the best way to equalize unusually large or small features. Move the camera angle closer to a small feature and away from a large feature.

FINISHING TOUCHES

Timing is everything. After spending time with your client on the phone, in a personal consultation, while setting your backgrounds and lights, the basic posing, etc., the final seconds prior to the click of the shutter are the most important. Your goal should be to gradually build up the energy level of the session to peak exactly when you make the exposure. Accurate timing is the difference between a good photograph and a great portrait.

> ...the final seconds prior to the click of the shutter are the most important.

● **EXPRESSION**

Whether you intend to have the subject smile, or look serious, ecstatic, sad, or provocative, your success will be mirrored in the subject's eyes. The twinkle in her eye will be your indication to trip the shutter, even if you're not totally finished with your posing,

Whatever mood you want to convey, your success will be reflected in the subject's eyes.

You can manufacture an expression, but the eyes and mouth will tell whether or not it is genuine.

lighting, etc. You can manufacture an expression, but the eyes and mouth will tell whether or not it is genuine. Your clients will relate to and connect with images that they see as being natural. Selling a portrait with a fake smile is difficult. Selling a portrait with a truthful expression is easy.

● MOOD

Historically, mood has been somewhat determined by trends. In the early, clamped-neck years, photographers were limited by long exposures. Stoic and even ill tempered expressions were common since they were easier to hold for the term of the exposure than an impulsive smile. As film speed grew faster, the sad/grouchy look endured probably because people were not accustomed to seeing people smile for portraits. Time passed and cameras became more portable and candid imagery became possible, and smiles were captured on film! The smile then became a requirement by the mothers of school children for years. Today, encouraged by children seeking individuality and the artistic resurgence of black and white photography, moody and somber expressions are making a comeback.

In the early, clamped-neck years, photographers were limited by long exposures.

The mouth is a strong competitor for the eyes for the most expressive facial feature. In fact, the mouth is less discreet in covering up the subject's true feelings. If you are attempting to obtain a certain expression, experiment with different vocal pronunciations, usually with vowels. Try to come up with something besides, "Say cheese." Having the subject wet her lips makes her lips appear more shiny and alive, but more importantly it is a good exercise for her facial muscles if the client is trying too hard to smile or has a dazed look. Certain words and word combinations, like "fuzzy pickles,"

are funny to children and are fun to use to get their attention, relax them, and render a good expression.

Knowing what mood to portray in a portrait can be difficult. It is always a safe bet to provide a variety of expressions. How other people perceive us, and how we perceive ourselves, is often different. High school seniors and their parents are constantly in conflict over expressions, particularly senior boys and their mothers. The

The mothers want their little boys to smile. The boys don't think it's cool to smile–they want to look tough and serious.

mothers want their little boys to smile. The boys don't think it's cool to smile—they want to look tough and serious. Do both and sell them both. Rely also on your study of the subject leading up to the session. But keep in mind that he may not be feeling well or be having a disagreement with his parent(s), friend, etc. You must be aware of this possibility when working with children. If they don't feel well, it is not fair to them or you to expect to get a natural

Knowing what mood to portray in a portrait can be difficult. It is always a safe bet to provide a variety of expressions.

expression. It may be best to reschedule the session rather than pressure and alienate the ill child.

For the most part, poses appear either assertive or passive, either dynamic or simple, and either exciting or shy. Traditionally, the mood you selected was often based on gender—men were assertive, women were passive. Current trends in certain types of portraiture are leaning away from this gender bias toward more neutral mood posing.

Soft, graceful poses for a woman, bride, or child are good applications for passive posing techniques. When posing a couple, posing a woman in a passive pose with a man in an assertive pose can make for a terrific portrait with lots of emotion. Having the subject shift her weight to her back foot while standing forces her to lean away from the camera, and will give a passive air to the pose. Also, having the subject tip her head down and toward her higher shoul-

Be careful when using passive posing, because the subject may appear bored or scared, giving him a "leave me alone" type appearance.

der, causing her to look up to the camera, gives another example of a passive pose.

Be careful when using passive posing, because the subject may appear bored or scared, giving her a "leave me alone" type appearance. Also, you may be in danger of positioning the subject in a way that makes her appear flat and heavy.

Assertive posing is the opposite of passive posing, and is generally more popular because it is more three-dimensional and expressive. Subjects posed in this way appear to be saying, "Here I am! This is me." Their personalities project from the image and have impact. Being that assertive poses are based on a forward lean toward the camera, they are more flattering as muscles are stretched and flexed as opposed to being compacted in a passive pose. Providing a posing tool, such as a table or fence rail, for the subject helps to facilitate a comfortable forward lean.

Subjects posed in this way appear to be saying, "Here I am! This is me."

● STYLE

Developing a portrait style takes practice, experience, and time. In a portrait style, posing is interdependent with artistic expression and technical abilities. Together, the three are at their peak when a portrait captures the feelings and emotions of the individual subject(s), transmits them directly to the viewer and evokes new feelings and emotions. An image that makes you smile, makes you think, or makes you want to cry has style. Posing contributes to your portrait style by arranging the subject to properly interconnect with another subject or her environment. A successful pose is practical and complements the image scene.

11

POSING TOOLS

To add another dimension to your posing, work with a variety of posing tools: furniture, special props, and sets. When collecting posing tools, consider size, shape, comfort, versatility, and safety.

By far, the most important criterion for posing tools is height. The greater number of posing levels that your posing tools can create, the more efficient you will be while setting up poses and the more attractive your portraits will be, particularly for groups. Your subjects can be positioned at different levels, as opposed to the static "line-up" style portraits.

Look for adjustable stools of different heights, sets of nesting boxes, benches, steps, etc. As a general rule for typical sitting head and shoulder poses, the stool, chair, etc. should position the subject so that his thighs slant slightly downward from the hip to the knee and his feet can rest flat on the ground. This is the most comfortable position for the body and will encourage good posture.

The most widely accepted height for a posing stool or bench for posing adults is 18″, but remember most people aren't exactly average. Using varied height posing tools will also allow you to use a wider variety of poses. Occasionally, you will find a posing tool, at a height when positioned in front of the subject, which will help you minimize the visual appearance of the subject's weight by using the Divide and Conquer Theory discussed earlier.

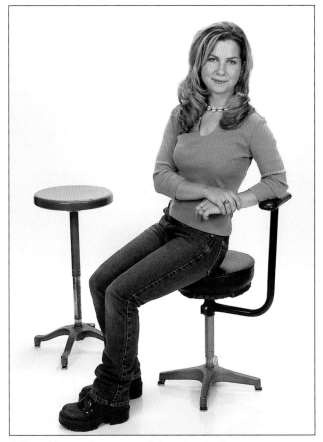

Adjustable stools are a useful posing tool.

Nesting boxes, benches, and other props can be effective posing tools.

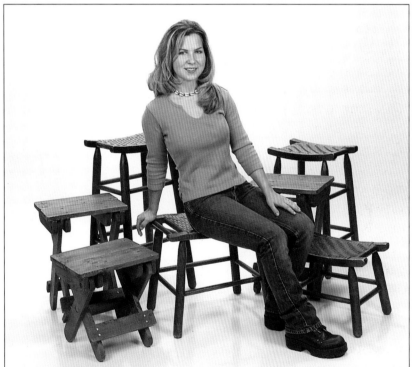

The width or "footprint" of a posing tool is critical when arranging a portrait of group, because you must take into consideration the amount of space accounted for by the chair, bench, etc. If, for example, the tool is a chair that is relatively wide, it will usually make it difficult for the members of the group to get close to each other. Thus, large light traps may be formed which separate the individuals in the group and destroy the feeling of unity. Also, if you are photographing the group with a limited depth of field,

large posing tools may make it difficult to keep the group within your range of focus.

Using a variety of shapes of posing tools will also help add diversity to your posing. A combination of straight-edged and curve-shaped posing tools will encourage using different types of poses. Curve-shaped posing tools are somewhat unique in portraits (i.e., round backed chairs, circle sets, etc.), making them visually attractive as well as functional.

Comfort of posing tools is a "Three Bears" type issue when pertaining to posing tools. For example, avoid a chair that is too hard, because it will become painful for the subject to sit upon. She will start to get uneasy and start to reposition herself to be more comfortable. Avoid a chair that is too soft, because the subject will sink in and it will be difficult for her to sit with good posture (books or boards may help to support the subject when on a soft chair). Chairs that are too high, leaving the subject's legs to dangle above the ground, are also very uncomfortable. So, choose the tool that is just right. It's a good idea to try before you buy. Because if you can't pose properly with the posing tool, don't expect your subject to. Many props, sets, and pieces of furniture end up sitting in the corner because even though they look nice, they don't provide a comfortable, natural base to pose upon.

A single posing tool may provide a number of posing levels and be photographed in many ways and look very different.

Keep in mind that a single posing tool may provide a number of posing levels and be photographed in many ways and look very different. A low back chair with low armrests presents three and possibly four locations for subjects to sit, not just one. Also, don't limit the potential of a posing tool by its traditional use. A parlor type chair can be sat upon normally, but may also be straddled or used when standing to lean upon with a hand or even a foot. In most situations, only a portion of the posing tool will be visible. So, visualize how different portions may be used in different ways: sitting, standing, leaning, arranged for depth, etc. Elaborate, detailed sets, such as those available from Off the Wall Productions, Inc., can be arranged in a multitude of ways to offer limitless posing levels as well as different looks. These sets are helpful to maintain portrait session flow, since you can move them quickly and easily and create a diverse collection of images for the subject.

Common sense should prevail when considering the safety of a posing tool. Height and sturdiness are the two main safety topics. If you place a child or a pet upon a table, or subject(s) on a ladder, be absolutely sure that he cannot fall off and be injured. A weak chair or stool should be repaired or replaced. Be careful when set-

The 3' high stepladder may be the most versatile and easiest to use posing tool available.

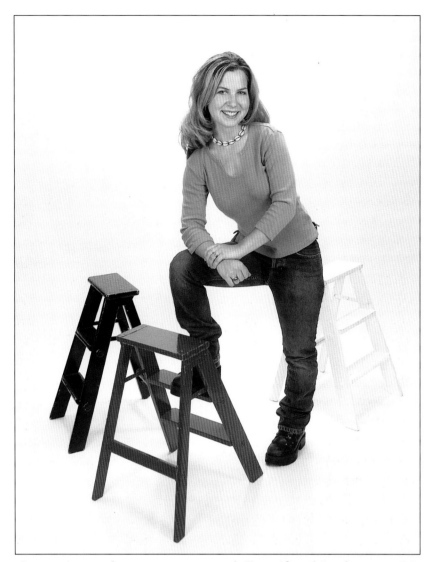

ting posing tools on uneven ground. Even if nothing happens, it's bad for your image and an expression of fear will show on your subject's face.

Following are a few of the popular posing tools:

The Three-Foot Stepladder. Although not the most elegant, and definitely not the most expensive, the 3' high stepladder may be the most versatile and easiest to use posing tool available. You can use it for a number of standing, sitting, and leaning poses, because it has three built-in posing levels. It's light, yet solid. It doesn't take up much space, and it's something your subject is familiar with. You can paint it different colors to coordinate with the subject's clothing or for the image theme. Best of all, you can use it for other purposes.

Carpet Pads. Another nonglamorous, cheap, but popular posing tool is the carpet pad. The carpet pad's (a.k.a. garbage bag or car floor mat) main purpose is to protect your subject's clothing from moisture and grass stains. But they also serve as great posing

targets. You can place it exactly where you want the subject to sit, and she rarely will move. If she does, she will automatically return to her spot.

Hard Foam Pieces or Small Boxes. Pieces of hard foam or small boxes that are 12"–18" square and in various heights between 1" and 6" high work very well for making slight adjustments in the heights of individuals in a group. They are particularly useful when the members of the group are of similar height. Cutting a hole in the center of the foam or boxes allows for a rope to be run through them and be stacked easily for carrying and storage.

Posing Tables. There are two basic styles of posing tables: the small adjustable height table and the larger fixed table. The small adjustable table is helpful for posing head and shoulders and head and arms type poses. By bringing the subject's hands and/or arms up onto the table, it forces his to lean at different angles than if he was standing or sitting normally. The lean is beneficial to the pose by stretching muscles and is more dynamic. Also, it helps relax the subject by providing him a comfort zone between you and him. Avoid setting the table too high which will force the subject to lean back away from the camera or setting the table too low which will force the subject to hunch over. Similar leaning poses can also be created with other tools, such as wooden split-rail fences, Dutch doors, and large wheels. The larger fixed table has been used for children, pet, and glamour portraiture. The subject is placed directly on the table, allowing you easier access to effective camera angles. Again, the height of the table is a safety concern, but note that the table doesn't need to be very high above the floor. A pet will tend to stay in one spot a bit longer when set on a table, because it is unsure of the situation.

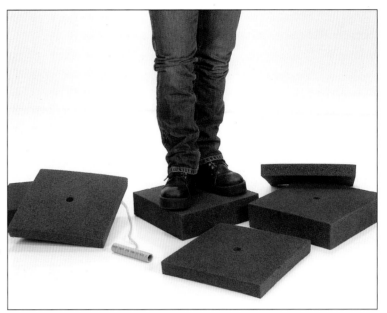

Hard blocks are useful for making height adjustments (top). Posing tables provide a comfort zone for the subject (bottom).

Steps. Steps and step-like props (available from Off the Wall, Ltd.) are solid, familiar platforms on which individuals and couples are easily posed. Their rigidity and built-in levels help the subjects pose naturally and comfortably. Props with step-like construction may also serve as shelves for placing items in a collection for activity style portrait.

Radios. A handy posing device is the two-way radio. When you are working at a distance from your subject and with ambient noise that makes it difficult to communicate (i.e., at a beach, near traffic, etc.), you can hide a radio behind the subject and use the other to tell her where and how to move. This will make your directions more understandable when you show the pose to your subject. Radios with Family Radio Service band frequencies are clear and nearly uninterrupted.

Just as we must continually analyze our poses to determine what works, what doesn't, and why, we must evaluate our posing tools. Again, you will find items that look great on their own, but are almost useless for posing. Conversely, you will find tools that aren't the most visually exciting, but are great posing tools. Once you find something that works, consider why, and look for other tools that are similar that may work as well.

> Conversely, you will find tools that aren't the most visually exciting, but are great posing tools.

The rigidity and built-in levels of steps help single subjects and groups pose naturally and comfortably.

ACTIVITY INVOLVEMENT STYLE POSING

Capturing the personalities, relationships, and feelings of your subject(s) through activity/involvement style posing takes your level of portrait art to a new level. On the surface, it seems that photographing a subject or group doing what they enjoy should be easy. It is and it isn't.

For example, during the consultation session with a family, you may learn that they enjoy camping, baseball, woodworking, etc. This provides you with topics to discuss during their portrait session to relax them, and also with possible themes to use to create an interactive portrait. You could photograph them setting up a tent or around a campfire, at the ball diamond, or building a new set of birdhouses. With the exception of individuals who believe a portrait must be formal and in front of a painted background, the subjects will almost always be more relaxed and involved in a session that portrays their true lifestyle and interests. You will be capturing a piece of their personal family history and love for each other.

The information gathered at a consultation session can provide possible themes for interactive portraits.

With interactive portraits, you still must strive to make the subjects look their best and appear connected with each other and their environment.

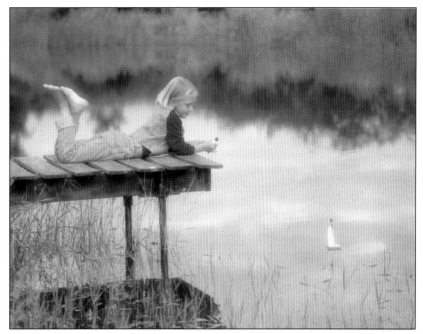

But, just as most good candids aren't just lucky grab shots, good activity/involvement style portraits don't just happen. Not only do they tend to lead you away from the comforts of your well-controlled camera room and into new lighting and compositional challenges, they also are limited by many of the same boundaries that occur in the "posed" portrait.

So, here's the conflict: you have the luxury of letting the subjects be themselves and not have to guide them into a pose, but you still must strive to make the subjects look their best and appear connected with each other or with another subject matter. Although clients will tend to be more forgiving when buying this style of portraiture, poses that make the individuals appear heavier, or make their clothes uneven, or make a group look unbalanced will not sell well regardless of the fun they had during the session. The images may not sell well both because the subjects may not be happy with

You may face working more with profiles than normal, which may be a test of your posing capability.

how they look, and because you may know you could have done better and not be able to enthusiastically recommend their purchase. Remember, you are compressing three dimensions into two, and what may look great visually may not look good on the final portrait. Also, you may face working more with profiles than normal, which may be a test of your posing capability. It is much like the challenge of photographing a mountain range. A valley of flowers towered over by a grand ridge of snow-capped peaks may be breathtaking, but capturing it all on film is a great challenge.

The portrait may simply be a child playing with her favorite toy or an old man carving a small wooden bird, but you still must ana-

lyze the lighting conditions, surrounding elements that may or may not complement the portrait theme, and how the subjects interrelate compositionally within the portrait. Relative to the pose of the subject(s), does your camera angle or lens

Is attention directed to one particular subject or does your eye look throughout the portrait?

selection help achieve your intended goal of the final portrait? Is attention directed to one particular subject or does your eye look throughout the portrait? Often, having members of a group focus their attention on a certain point in space, a subject, or one specific member of the group (i.e., a baby, a pet, the campfire, etc.) can be effective for recreating a time in their life.

Practice and preparation will be your best weapons in creating activity/involvement portraits. Being in control of the technical factors of photography and remembering sound posing techniques will allow you to be ready to capture personal interaction either as it happens or be able to recreate it quickly and convincingly.

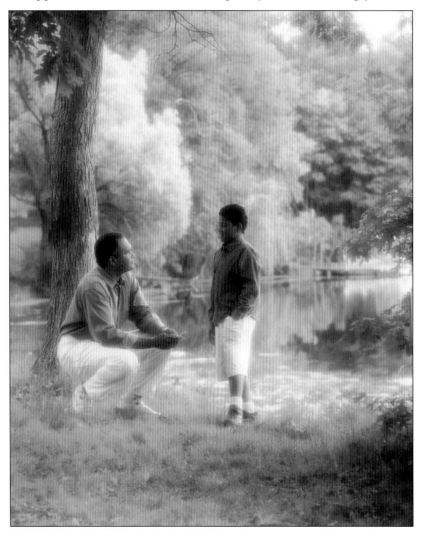

Interactive portraits demand skills in the technical aspects of photography as well as sound posing techniques.

POSING FOR SALES AND EFFICIENCY

The days of "Turn your head" (click!). "Turn your head" (click!). "Okay, we're done. Thank you," are long gone. The growth of the portrait industry, competitive forces, and societal influences have forced more detailed and elaborate portrait sessions, with few exceptions. Not only do you have to learn to elude the ever present, "that's not his smile," once, but you must do it repeatedly with different clothing changes, hairstyles, backgrounds, etc.

The high school senior market is an excellent case in point. A quality head and shoulders portrait for the yearbook simply just isn't enough. Yet, the average senior isn't a model, and she can't hold a comfortable expression for very long. There are two ways to attack this problem. Some photographers only photograph a few seniors per day and spend a few hours with each, allowing for time for rest and rejuvenation between set changes or traveling to different locations. Thus, their sessions are truly a series of many mini-sessions, starting fresh at each one. Other photographers schedule a large number of seniors per day and strive to build up maximum excitement and then fly through one session. Both "endurance" and "sprint" type sessions have positives and negatives. Endurance type sessions provide more time for the photographer and subject to become more comfortable, but sometimes, even with breaks, both the photographer and subject may become tired or bored. Adversely, sprint sessions have a high energy level throughout, but may risk making the subject feel rushed or unimportant.

Neither the endurance, nor the sprint type sessions are right or wrong. Which style you prefer or develop will depend greatly upon

Sprint sessions have a high energy level throughout, but may risk making the subject feel rushed or unimportant.

your own personality. Either style you choose will be aided by a few posing concepts that will help maximize your sales and efficiency:

● SHOOT IN SERIES

If we accurately position the subject from the ground up, there are a number of opportunities to photograph him in the same basic overall pose with different camera angles, crops, and expressions,

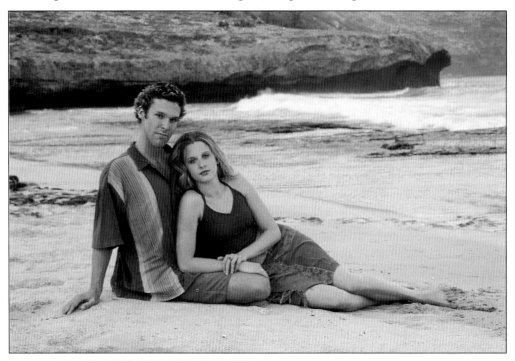

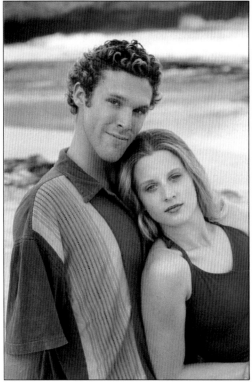

If you position the subjects from the ground up, there are multiple options for photographing them with different camera angles, crops, and expressions.

thus yielding a variety of strong images without reposing, relighting, etc. For example, a full-length sitting pose may look great for a three-quarter-length pose, and a close-up pose. If a pose works, maximize its potential. The subject won't tell his friends, "Hey, I was in the same pose in this image, and in this image, etc." Chances are he won't remember, nor will he care. What will matter to him the most is that they're different and he likes his expressions. Shooting in series works well with insecure and unmotivated subjects. The more images you take without spending too much time repositioning him, correcting him, etc., the more confident he will become since he feels like he's doing his job well.

● BUILDING UP AND BREAKING DOWN

With one added twist, shooting in series can be done with groups as well. Wedding party portraits at weddings are the perfect example. First, start with the bride, then add the groom, then add the best man and maid of honor, then add the rest of the wedding party, then photograph the men and then the women, etc. This system adds continuity and saves valuable time. Plus, you reap the added benefit of drawing on their recent posing experience as you progress. Always offer to break a large family group or staff group down into additional subgroups or possibly even individuals. Each individual group will have a meaning your clients. Simply put, you can't sell images you didn't shoot!

Always offer to break a large family group or staff group down into additional subgroups or possibly even individuals.

● USING THE "RIGHT" POSES

You can't set your subject on an X, in the same pose, with the same light and same background and expect to get good portraits all the time. Poses must be tailored to fit the individual. Again, the consultation session will be very valuable. Knowing what the subject does naturally and analyzing her potential for different poses will pay off later in sales. Don't get stuck using the same pose for everyone, but don't be afraid to use the same pose a few times in different situations with the same subject. A great number of issues will affect whether the pose is the "right" pose. Common sense should prevail, and usually, if it looks good, click the shutter!

● POSING FOR VARIED TASTES AND PREFERENCES

For example, pose the subject traditionally for the grandparents and in an activity style for himself and his parents. Try a few non-traditional poses for the subject and for your own artistic interests. Don't be discouraged by below average initial sales of non-tradi-

tional poses. Done well, they might attract attention to your work and serve as marketing tools that will bring in additional clients and sales in the long run.

Tailor your pose and style for different tastes—perhaps creating one portrait for the grandparents (facing page), and a different portrait for the subject.

● SCENIC PORTRAITS

Portraits in an attractive setting that leave space around the subject(s) will help encourage larger portrait sales. Combining good posing, composition, and sales techniques will lead the client to buy a larger portrait for a couple of reasons. When the subject is relatively small in the scene, larger prints are necessary to properly show him. The client may be more likely to hang a large portrait in his home if it is more of an artistic scenic piece than the typical smiling head and shoulders portrait. Also, the client may find it easier to purchase a large image that shows something he treasures, such as his farm, home, car, etc., than just an image of himself.

Environmental portraits like this may encourage clients to purchase larger portraits to hang in their homes as art pieces.

POSING ON LOCATION

The best part of photographing portraits on-location is that each location is unique. The worst part of photographing portraits on-location is that each location is unique. The on-location portraiture market is just waiting for you to enter.

The most common on-location portraits are where your subject(s) is/are either inside or outside their home, cabin, business, or at their favorite outdoor spot. None of these locations are your camera room, but with practice and experience, you can make them act just like your camera room: a combination of light sources, a background, and posing tools/levels. Breaking the location down into these three elements will make your sessions more efficient, improve your portraits artistically, and make them more saleable.

Breaking the location down into these three elements will make your sessions more efficient . . .

● LIGHT SOURCES

The first element to consider when posing on-location is light source. Whether you are working indoors or out, you should aim to replicate your main light source, fill light source, etc. as you would in your studio and work to balance them with the existing light sources. This is oversimplifying lighting for on-location portraiture, and the topic is worth volumes in itself. But the fundamental viewpoint is accurate.

Three lighting issues deserve particular attention since they affect how and where you will pose your subject(s): intensity, quality, and direction. All three will help determine where you pose your subjects, unless your client requests a specific spot, where you will need to be able to adapt the lighting to meet your portrait

Lighting quality and direction should be a major factor in your decision to use a particular location for a portrait.

needs. If you have some flexibility about where to pose, you will look for light intensity that is within a controllable exposure range, light quality which is appropriate for the theme of the portrait (either hard or soft), and light direction which can be used to create dimension (a.k.a. lighting ratio) to the appearance of your subject(s). Leon Kennamer, a legend of environmental portraiture, used trees or similar structures to help identify good portrait locations. If you examine the light falling on the tree, it will tell you the intensity of the light by how light or dark it appears, it will tell you the quality of the light by the hardness or softness of the transition between highlights and shadows, and it will tell you the direction of the primary light source by the placement of highlights and shadows on its circumference.

Examining the light falling on a tree will tell you the intensity and quality of the light.

A subject's facial features can provide similar lighting clues. A well defined "Angel's Touch" or "Cupid's Bow" (the notch between the nose and upper lip) will appear deeper when the light direction is at its best angle for dimensional lighting. The triangular, "Rembrandt Patch," cast by the nose on the cheek opposite the

primary light source, will become more defined at this light angle. Watch how the illumination of the color of the eye changes and a crescent glow becomes more defined as you turn your subject's head. Deep shadows underneath the eyes are telltale signs of a hard light source coming from overhead.

Windows and water bodies are unique light sources. Often, photographers make the mistake of thinking that they are only usable for backgrounds and don't recognize their distinct qualities as light sources. Due to their relatively high brightness level in a portrait scene, they are often too bright and distracting, except for high key type portraits. Try photographing at an angle that is closer to parallel to them as opposed to perpendicular. The difference of brightness of daytime sunlight entering a normally lit room through a window and the reflective qualities of water make them excellent primary light sources if their intensity is within your controllable exposure range. Light reflecting off of water can be particularly useful on dull days where other locations appear too flat.

Once you have identified the primary light source involved, you will use it to position your subjects. A simple yet effective method when posing on-location is to turn the subject's weight (primarily feet, legs, and hips) away from the primary light source, turn her head back toward the light source to achieve dimensional lighting on the face, and tip the head to imply masculinity or femininity. This maneuver will define and enhance the shape of the subject and maximize the color saturation and

Once you have identified the primary light source involved, you will use it to position your subjects.

detail of her clothing. When working under mixed lighting conditions, you will need to either overpower the ambient light with artificial light sources, and/or position your subject accordingly.

● THE BACKGROUND

Normally, it is something included in the scene behind your subject that is the purpose of the on-location portrait: a home, natural land or sea features, interior architecture or furniture, etc. Scene brightness and composition are the two key factors to consider when selecting your angle to view the portrait's background and the placement of the subject(s).

Scene brightness is another issue dealing with light, not as a light source, but how it falls on different areas in your image scene. Basically, determine if these areas are illuminated properly to draw or divert attention and to complement or contrast your subject. To create depth and draw attention to your subject(s), try to find angles and cropping points that highlight your subject and let the background areas receive more subdued lighting. Avoid back-

Avoid background areas that are not necessary and are "hotspots," areas that are overly bright and distracting. Here, the colored leaves set the mood without overwhelming the subject.

ground areas that are not necessary and are "hotspots," areas that are overly bright and distracting. Sky above and between trees or buildings are examples of this problem. Using a higher camera angle may be the remedy. If you have uneven, uncontrollable light and/or dark areas on a necessary element or area, such as your subject's home, choosing another time of day or side of the house would be recommended.

Experimentation with camera angles, lens focal lengths, and subject placement are important for control of scene composition when you are attempting to include a secondary subject matter. Again, the compression of the three visual dimensions into two on film presents a challenge when trying to include a secondary subject, especially when it is quite large, like a house. Choose angles and lenses that place the subject toward a corner of your image and the secondary subject toward an opposite corner. Camera angle and lens selection are significant when photographing a portrait indoors, also. They will determine what parts of the interior are included within the final portrait and which will be left out.

Sometimes, wide-angle lenses are your only choice, because of depth restraints in a room. Be aware of natural and/or structural leading lines, such as fences, and framing objects, such as branches and windows, that can enhance the artistic compositional value of the portrait.

Although composition can help place your subject, it can limit your posing opportunities and you must be able to adapt. For example, a high camera angle required by the scene composition may make your subject look too small. So, you will either need to change the camera angle or the height of your subject by changing his pose or adding a posing tool.

Although composition can help place your subject, it can limit your posing opportunities and you must be able to adapt.

● FINDING EXISTING POSING TOOLS/LEVELS

As a professional portrait photographer, you should develop a keen eye for existing posing tools and levels when creating portraits on-location. Use them to create depth in your portraits and to develop dynamic arrangements of groups.

Certainly, you can take your favorite posing tools out of your camera room and use them on location. But sometimes it isn't practical, or they might not be appropriate in the portrait scene. However, the same factors apply when looking for existing tools or levels as do for your camera room posing tools: size, shape, comfort, and safety (See Posing Tools). Look for furniture, rocks, logs, etc. that are of varied heights and of widths and shapes that are complementary with each other and safe for your subjects.

Posing levels can be simple natural rises or slopes in the landscape or steps, or be as complex as multistory architectural structures. Look for groups of levels that are arranged dynamically in a triangle or at a diagonal. Mounds of land are perfect posing platforms for families, because they naturally place the individuals in a triangular arrangement.

OTHER POSING CHALLENGES

15

Following is a series of specific challenges that you may face during a portrait session that directly affect how you pose your subject(s):

● CLIENTS' IDEAS

Clients' ideas can be the key to the ultimate portrait experience if handled properly. Positive client involvement can make your job easier, and more rewarding. Knowing that they are truly excited about having a portrait made is exhilarating! Plus, the more they are involved in the process, the more willing they will be to invest in your work. Unfortunately, our clients often don't know what they want, but have preconceived illusions about portraiture. They may only know portraiture by something they saw on a television show, by their experience at the department store studio, or by their church directory session.

Educating your client base is the most effective way to help your clients help you. This will not happen overnight, though. Again, the consultation session is a powerful tool. Consistently showing quality portraiture in your advertising and displays will pay off eventually as well. But the best way of all is from word of mouth. If you do a good job for a family, for example, they will tell others about your work and show them their portraits. Next, you start to receive calls saying, "I just saw the Smith's family portrait, and it was just beautiful. We want our family portrait done just like theirs." So, indirectly, you are achieving the goals you set, while the client is confident that they are getting what they want.

There will be times that your clients may present you with ideas that they think they want, a specific pose they saw in a magazine,

> Educating your client base is the most effective way to help your clients help you.

for example. But you know that it is not appropriate for them. It would be advisable to do what they ask (because we all know they're always right), and then do what you know is best. More often than not, they will pick what you felt was best. A few frames of film aren't worth the risk of angering or even losing your client.

● CLOTHING

Clothing can enhance a good pose or ruin it. Knowing how the clothing conforms to the body, how fabric folds, and how it reflects light, are all issues in posing since it may draw attention to specific areas of the body and have positive or negative effects. Consider a bride's dress. On the positive side, it can be arranged to flow and form triangles and leading lines and improve the composition of a portrait. On the other hand, if not handled properly, it can become bulky and add the illusion of extra weight.

Let your clients know that it is important that their clothing fits properly. If it doesn't, you will be constantly pulling and tugging on it and repositioning the subject—and she will quickly become frustrated and uneasy.

A common clothing conflict is a mismatch of clothing style and the portrait theme. Many people feel that you must wear formal clothing, but choose to have an informal outdoor portrait. Suits and dresses often look out of place sitting in the grass or leaves. They limit the subject's mobility and tend to wrinkle and bunch up.

Some particular clothing items pose special challenges. Hats cast shadows and are sometimes better held in hand rather than worn. The primary difficulty with hats is the shadow they cast from their brim across the subject's face. If your

A few frames of film aren't worth the risk of angering or even losing your client.

light source is fixed, you have to raise his head to minimize the shadow, and you lose control of the pose of the head, eyes, etc. A more desirable alteration would be to move the main light source or add a new one with a flash or reflector. Suit coats wrinkle and buckle easily. Try using standing poses for head and shoulders portraits instead of sitting to help to avoid these problems. Lettered jackets are popular with high school seniors, but the words may be difficult to read when worn. Many lettering problems can be solved through simple positioning of the fabric and experimentation with different poses and camera angles. Sometimes hanging it on a hangar next to or behind the subject will help.

● HAIRSTYLES

Like clothing, hair can add or detract from a pose. Your subject can change her clothes and change her hair, but there's more to it than

For portraiture, long hair is more versatile than short hair and can be arranged in different ways.

that. Your subject's hair is a more personal issue. Rarely will you dictate your subject's haircut for a portrait session. Unless you are a stylist, you won't be changing her hairstyle. Remember; don't touch your subject's hair unless you absolutely have to, and only *after* you ask for her permission.

Hair length is the most obvious factor that affects posing. Long hair is more versatile than short hair. It can be arranged in different ways. It can be flowing. It can blow in the wind, and so on. But it can also cause problems. Try to keep long hair from falling around the neck and forming the appearance of a beard. Be aware of the shadows cast by hair falling in front of your subject's face. When your subject tips her head to one side, her hair may get caught. Try having the subject move her hair completely behind her, or move her hair in front on the side her head is tipped toward. For both long and short hair, be aware of the light falling on it. Light will change the appearance of hair shape, color, and brightness.

● POSING WITH VEHICLES, LARGE ANIMALS, PROPS, ETC.

Unless you have a large crew and a Hollywood set, photographing an individual with his car, horse, harp, etc. is a whole new dimension of portraiture. As compared to the portrait of an individual alone, these types of images can become very challenging as posing, lighting, background, and spatial concerns grow exponentially. Usually, you are forced to compromise your individual's pose to accommodate the second subject.

When posing your subject with a vehicle, it is often the case that you find a location the vehicle can be driven to safely and that has even lighting. Then you can position your subject accordingly. Keep in mind that the vehicle may be as or even more important to the client than the subject(s) posed with it. So, make an effort to ensure it look its best as well. Try to schedule these sessions either early in the morning or later in the evening, if possible, to make use of the softer lighting conditions. Dull days are also good. The light on the vehicle will be even and then you can add artificial light to illuminate the subject.

Once you have positioned the vehicle, experiment with different ways to pose your subject with it. Vehicles provide a variety of areas to lean against, which is particularly useful for a male subject.

You can lean him against the door, the fender, the bumper, even the hood. Sometimes you can place a woman or child directly on the hood or roof of the vehicle.

For all poses, however, you must try to exercise good posing methods to flatter the subject. This can be awkward, since you are using uneven surfaces to pose on or against. This means that experimentation with various poses and camera angles is essential. Besides posing the subject directly with the vehicle, try posing him normally on the ground or next to another structure or tree, with the vehicle as a secondary subject in the background. This technique is useful when the vehicle is very large, such as an airplane, and will be too dominating when you pose the subject close to it.

Posing on uneven surfaces, such as a car, requires experimentation.

Posing with any size animal can try the patience of any photographer. Posing a two-year-old child with a cat may just be the ultimate challenge! Posing with large animals such as horses, cows, etc. can be very complicated. These animals are usually not as trained as a smaller animal such as a dog and it isn't as easy to gain their attention. Again, it is a matter of posing the animal and then adding the subject. Posing the animal will vary from one to anoth-

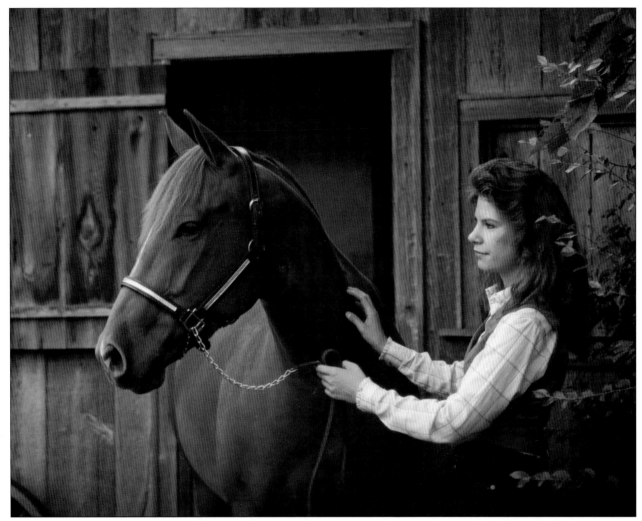

Posing the subject with an animal is very similar to posing with a vehicle, except that you must be quick to pose the subject once the animal is positioned.

er. It is worthwhile to research the proper positioning of animals, especially when the animal is owned for competition and/or breeding. The search for the best way to get a horse's ears up and forward in a portrait is never ending. Practice, planning, experience, and flexibility are priceless. It is also helpful to have photographed the subject previously without the animal so that she has some posing experience and is familiar with your style and directions. Posing the subject with an animal is very similar to posing with a vehicle, except that you must be quick to pose the subject once the animal is positioned. Rarely will the animal hold a pose for more than a few seconds unless it is specially trained for shows.

Occasionally, your clients will ask to be photographed with items that are not exactly ordinary and not something you photograph every day. For example, they may want their musical instruments, their large paintings, their collections of rifles, etc. Besides your basic photographic experience, your willingness to learn about their prize possessions or hobby will play a major role in the success of their final portraits. If the challenge is completely new to you, do

not wait until the portrait session to start doing your homework. Let the subject tell you what is important about his specific item. It is important to him, and he probably knows much more about it than you do. Ask him if he has examples of similar images, possibly from magazines, books, etc. that will help you get ideas about how it should look. Be careful when posing with instruments or other devices to not position it or the subject in such a way that is inaccurate. But don't be afraid to study them from various angles and experiment.

Sometimes, allowing an animal to act naturally can yield a beautiful portrait.

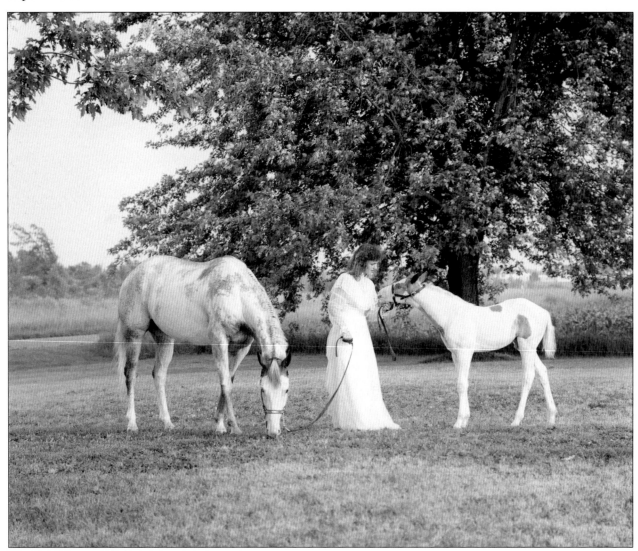

● THE BUSINESS PORTRAIT

Photographing the executive encompasses many of the issues discussed so far plus a few new ones. When photographing the businessperson, control of the attitude of the final portrait deserves special attention. You will need to position the subject to properly project his position or personality. If your subject is an officer, for example, lower camera angles and square shoulders and hips will

accentuate size and express power, while relaxed, happier, more casual poses and expressions will portray friendliness and openness for a salesperson, possibly for an annual report. In either case, you should be prepared to work comfortably under time restraints, specific demands by advertising departments, and with problematic personalities.

● CREATIVE/ARTISTIC PORTRAITS

If portraiture is an art, then you should always be seeking a new creative way to pose, compose, and expose your images. Challenge yourself. Study other art forms and transform them into your portraiture. Not only may your experimentation yield fine pieces of art, but also it will provide you with new twists to use on your everyday sessions. Also, it keeps you fresh and helps to prevent burnout.

Always be on the lookout for new ideas for props and posing.

If you can, try something new with each client. Who knows? Maybe he'll like it. Sometimes he won't. But the inspiration and education you gained by doing it could be much more valuable in the long run of your career.

● SIMPLE POSES THAT SELL

Occasionally, you will find a pose that makes up for some of your difficult challenges. It's easy, and it sells. Enjoy these poses even if they're not your particular favorites, or you're tired of doing them. Portraiture is an art, but for most, it's also a livelihood. Obviously, there is something about them that your clients like, and remember who's always right. Yes, it's the keeper of the checkbook!

● CHALLENGES IN GENERAL

A key point to remember when faced with a difficult situation is to view it as a challenge and not as a burden. Otherwise, your client will sense your despair, she may question your abilities as a professional, and she will become more tense and difficult to pose. Again, educating the client beforehand will help minimize such surprises. If there is a severe problem, explain to her why it's a problem and how it will negatively affect her portraits. If she is insistent, let her know that you will do your best.

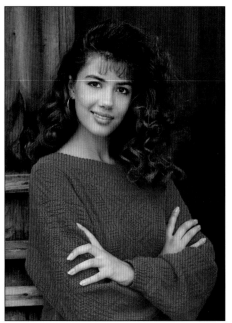

Even if they are not your personal favorites, sometimes you will find simple poses that sell again and again. When you find these, use them! Photography is not only an art, after all. It's also a livelihood.

Posing in Practice

16

CHILDREN

● **PSYCHOLOGY**

Be Prepared. Work fast. Be ready for any-thing. Try anything. Timing is everything. You rarely have the luxury of building a rela-tionship with your subjects in this case. They get tired, bored, and upset easily. You're working on their terms. Have your set ready (backgrounds, lighting, camera, etc.) and fixed. Work as a team if possible, usually with their parents. One watches their safety and one helps you gain their attention and expressions.

Be Patient and Flexible. Be aware of chil-dren's natural behaviors while you work toward your posing goals. Don't be afraid to "just take the picture." You'll be surprised by what you get, and by what your clients will order. Find out what posing tools, words, etc. work, quickly, and then use them repeatedly. Each child is different and will require different treatment. If she's not feel-ing well, consider rescheduling her session rather than pressuring her. You won't get comfortable expressions, you'll risk implanting a bad memory of her portrait session and hurting future potential sessions.

Work Closely. Babies especially have a short field of vision. So stay close and/or have their parents close by. Use a soft, consistent, happy tone of voice to relax them.

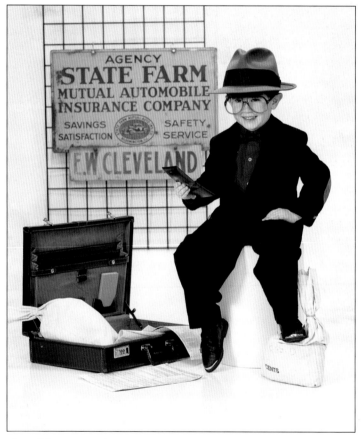

Posing stools and other devices (like the "money bag" in this photo) help support kids in the right pose and make them more comfortable.

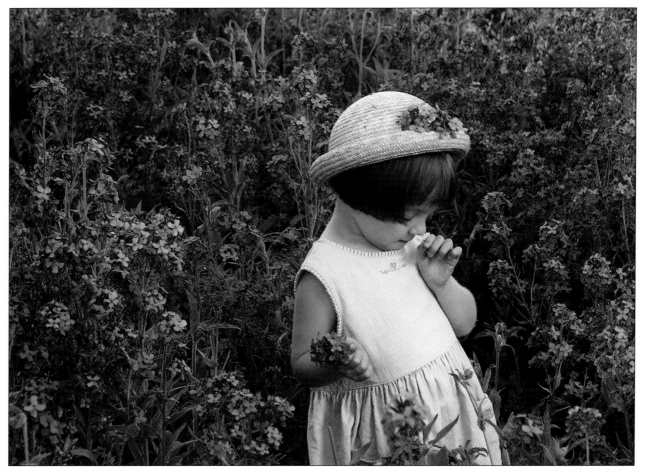

Distractions, like holding and smelling some flowers, can help make children feel more secure. This helps create more natural poses.

Feeling at Home. "She smiles so nice at home." Do the best you can to make your working environment more like home and less like a doctor's office. Have a few toys and stuffed animals that may function as security blankets. Also, pets such as birds and fish at your studio work well as welcome distractions from what is otherwise an unfamiliar place.

● MECHANICS

The Eyes. Physically, the innocent eyes of a child are priceless in portraiture. Whether, they're sparkling with excitement or quietly closed while sleeping, they are a key factor to highlight in your portraits.

Posing Tools. Steps make great posing tools for small children. They help them sit erect and comfortably, because they are well supported on their bottoms and their feet. Also, steps are familiar to them as compared to posing stools, etc. Posing tables are also helpful to bring them to a height where they are more accessible and at a better viewpoint for your camera.

Composition. As a general rule, give a child room to grow in the overall layout of his portrait. Closely cropped images of children and babies make them appear overly large and unnatural, with the

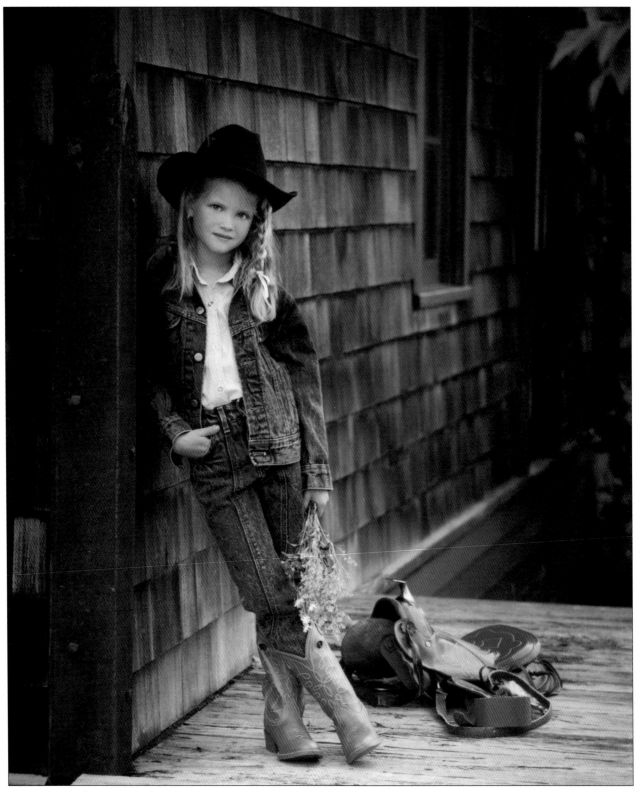

exception of extreme close-ups focusing mainly on their beautiful eyes.

The innocent eyes of a child are priceless in portraiture.

 Clothing. A difficult challenge for babies and children is when they are dressed up by mom or Grandma in their new outfit that they aren't familiar with and don't feel comfortable in. Make this

point clear to the parents, so they realize how their child is feeling. If there is an obvious problem, start simple with familiar clothes, and work toward the desired outfit. Avoid constricting, tight pieces of clothing if possible.

Children often don't feel comfortable when they are all dressed up in new clothes. Because of this, it's often best to start with familiar outfits, and move toward the desired clothing.

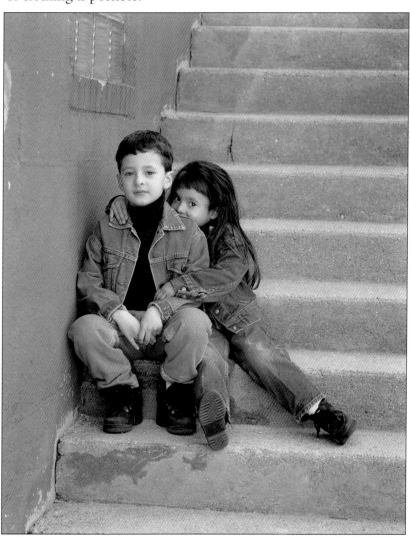

● KEY STRATEGIES

Bubbles. A long-time favorite of baby photographers is the beloved bottle of bubbles with the bubble wand. Something about bubbles brings smiles to children's faces every time. Also, they can magically change a mood of a session in a second.

Involvement. Most children do not handle the pressure of "Smile!" very well and react much better when given something to do or hold. A doll, a ball, a book, etc. can be fun for them and will break the pressure and provide opportunities for improved portraits.

High School Seniors

● PSYCHOLOGY

Fun. Seniors are at a difficult transition period in their lives: leaving home, going to college, girlfriends/boyfriends, etc. and may be a bit insecure. Their portraits and portrait sessions are an important step in their life at the time. Make the session interactive. Have fun yourself. They will feed off of your excitement if you let it show. It will help minimize awkward periods of silence that will make them uneasy.

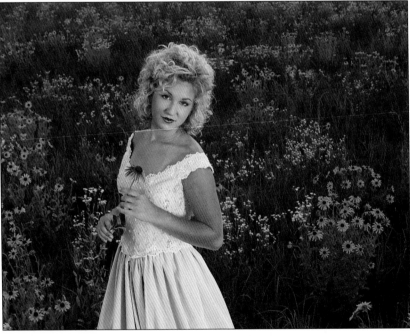

Be Flexible. The seniors are individuals and are proud of it. A pose one likes another will hate. It's nobody's fault.

R-E-S-P-E-C-T. Treat your seniors like young adults. Try to take interest in them and their ideas. Ask them questions about their plans and hobbies. If you're sincere, it may be refreshing for them to be treated with respect and not like just another kid. If you earn their respect, they'll be more involved and cooperative.

Don't Prejudge. Never think that because how a senior subject looks or dresses or reacts will determine how he will value and will invest in your portraiture.

Family Conflict. Experience with working with people is invaluable when working with seniors and their parents. Usually, the par-

Above and Facing Page: Senior portrait sessions should be fun and interactive. Be flexible and talk to high school seniors like young adults, not children.

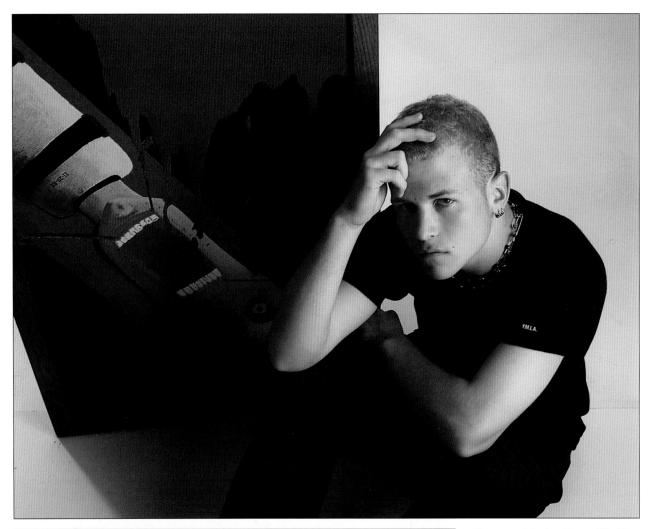

Above and Facing Page: Working through the concerns of the senior and his or her parents prior to the portrait session will allow you to focus on the subject.

ents are involved in some way during their son's or daughter's portrait experience. If possible, try to work through their concerns prior to the portrait session so that you can focus on the subject. Ask questions before you begin to avoid surprises later.

● MECHANICS

Variety. Possibly the most dynamic and complex field of portraiture is high school senior portraiture. "Contract" type sessions still exist where head and shoulders poses rule, but for every contract photographer there are fifty studios aiming to sell "experience" type sessions. Due to a number of societal changes, these subjects expect more to choose from than three turns of their head. You must deliver more poses (head and shoulders, ¾-length, and full-length), angles, expressions, moods, etc. An arsenal of backgrounds, sets, props, outdoor scenes, etc. have become essential. They expect to get what they see on TV. Practice, practice, practice, and learn. The pre-session consultation is very important to determine their wants and needs.

Senior portrait photography is a dynamic and complex field—subjects expect a variety of unique images to choose from.

90 High School Seniors

Can't Miss Poses. Find poses that you know you can do quickly, easily, and sell well and have them ready. The "Leaner" pose is one such pose (below, left) Take the average senior guy who comes to you because, "Ma said I had to get my pictures taken." Take a three-foot stepladder, have him put his foot on the second step, lean his arm across his elevated leg, and grab his wrist. From that pose, you can shoot good head and shoulders, three-quarter, and full-length poses with different lighting, backgrounds, etc. without him barely moving. You can add his girlfriend easily by having her step in and grab his arm (below, right). Quickly, he'll be relaxed and realize that it's not that bad after all.

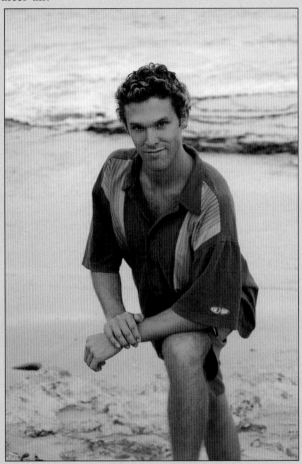 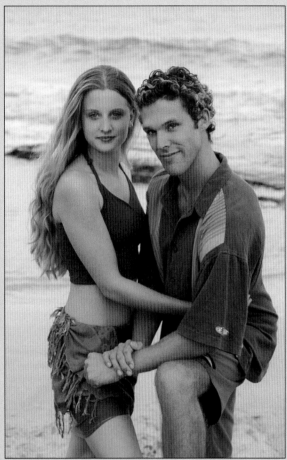

Be Trend Savvy. Like hair and clothing trends, certain poses and posing tools come and go and come back. For example, the '70s profile poses showing a girl's long hair are regaining popularity. Certain props, furniture, etc. can become dated, as well.

Experiment. Don't get too locked in with certain poses. First, use what you know will work, but try new ideas. It will keep your poses from getting stale and will keep potential clients interested in your work.

18

Men

● **PSYCHOLOGY**

Keep it Simple. Men are, by nature, generally less detail oriented and more nervous. Thus, it is best to keep your session quick by knowing your equipment and by not taking too much time between images.

Never Assume. Women are usually credited for taking the greatest interest in portraiture, which is probably true. But don't assume the man doesn't care how his portrait looks just because he doesn't say it. Remember, he has an ego, too. Show interest in him and ask for his input.

● **MECHANICS**

Men are Leaners! If there's a doorway, a tree stump, a desk, a chair, a car, or a bar rail, the average man will find a way to lean on it. So, use this trait in your posing. It will be easy for the subject, and will look appropriate. But still aim for good posture and avoid slouches that will make the subject appear bored and not flatter his physique.

Masculinity. Pose men dynamically, leaning toward the camera, not away. Visualize the classic C-poses where the shoulders are tipped and the head is tipped to the lower shoulder to where it becomes perpendicular to the shoulders. Breaking these rules will quickly imply passivity and femininity. The brow, nose, cheeks, and chin of the man are more pro-

Leaning poses are excellent for male subjects.

Left and Below: Pose men dynamically, leaning toward the camera, not away.

nounced than with a woman and should be accentuated with your posing and lighting. Fists, knuckles, and crossed arms shouldn't be overused in male portraiture, but are more appropriate than in portraits of women.

Getting your subject involved with his environment can be a fresh and effective posing technique.

● KEY STRATEGIES

Watch and Learn. Most men have habits that can be used for posing. Some men often put their hands in their pockets, some cross their arms; others are very expressive with their hands. Reproducing these habits during the session will be easier for you and them and their final portraits will be more representative of their true personality.

Involvement. Rather than canned poses, getting your subject involved with his activity or environment can be effective. For example, a portrait of a man working on his favorite craft or at his desk may be more suitable than just sitting on a stool and smiling.

WOMEN

● PSYCHOLOGY

A Woman's Touch. Statistically, women have the greatest involvement and influence in portrait sales. Encourage their input, listen, and incorporate their ideas. Paying attention to details they find important will impress and relax them. They will be reassured that they chose the right photographer and will be more willing to accept your ideas.

Be sensitive. Because women are more openly conscious of their appearance, be sensitive to their concerns and reassure them that you will do your best to make them look their best in their portrait. A misspoken word or phrase may irritate the subject to the point where getting a comfortable pose and expression may become difficult.

● MECHANICS

Gracefulness and Femininity. Place the woman's arms, legs, hair, and hands to create longer, more flowing lines. For the classic S-curve pose (which may be better visualized as a lightning bolt pattern), the subject tips her lower shoulder toward her higher hip and her head toward her higher shoulder. Pay close attention to good posture: stretching and turning to tighten muscles. Show the edge of the hand instead of the back and knuckles. In a standing pose, shift the weight to the back foot and carefully position the front foot and leg to accentuate its tone and beauty. Avoid squared shoulders and hips that will appear static and uninteresting.

Posing for women should generally accentuate the subject's gracefulness and femininity.

The Eyes. Effective posing of the subject's eyes is vital to any type of portraiture, but is somewhat more important in portraits of women and of children. Because women have relatively smaller brows, foreheads, and noses than men, their eyes are more pronounced and are more noticeably expressive. Getting light into the eyes is critical. Tipping a woman's head slightly downward and having the eyes look up to the camera maximizes the appearance of the whites of the eyes and makes them more beautiful and glamorous. Turning the head away from the camera and having the eyes look back toward the camera will have the same effect.

Because women have smaller brows, foreheads and noses than men, their eyes are more pronounced. That makes posing the eyes all the more important for portraits of women.

Glamour. Women are still the primary subjects of glamour portraiture, which is a market that has changed drastically due to the competitive influence of chain portrait studios. A good guideline to use when creating a glamour portrait is to pose and light the subject to really project her most positive attributes and hide her most negative. Simply ask her what they feel they are. She may be particularly proud of some and not of others. Emphasizing the principles of the classic S-curve and posture will draw attention to the female form and the graceful pose will become sexier and more seductive. Again, the eyes are very important.

> ● **KEY STRATEGY**
> *Build Excitement.* Women are more apt to be excited about portraiture. Build on this excitement. It will carry through from the first phone inquiry to the final portrait delivery and beyond. Positive word of mouth is a great asset when creating fine portraits of women.

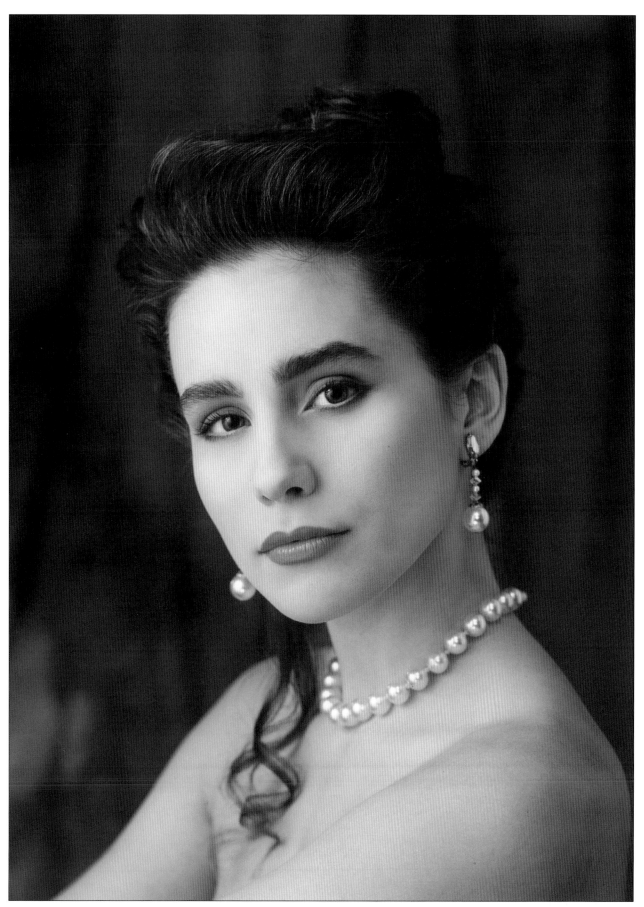

20

BRIDES, GROOMS & WEDDINGS

● **PSYCHOLOGY**

Love is in the Air. More than any other type of portraiture, wedding portraits should capture the love between the bride and the groom and from their family and friends. Certainly, recording images of groups and events on the big day is essential. But it shouldn't overshadow the opportunity for you to create images that show love. Everyone is dressed in their best, happy (well, usually), and having fun. Make the most of it. Be creative and be prepared to capture special moments that just happen and are nearly impossible to recreate.

Mutual Respect. Portray yourself as a professional and let your subjects know they are important to you. Let them know that you want to create fantastic images that they will treasure forever, but don't want to interfere with their wedding day. Have a plan and let them know what it is. They will respect you and be more cooperative. It will be a win-win situation.

Keep Your Cool. "Wedding Photographer Horror Stories" could be the next best-selling thriller. Expect anything to happen and be ready to adapt. Make it clear that you are trying to do your best for them, but don't argue or be agitated. Many of the people

Be creative, have fun and be ready to capture images that show unique moments and relationships—even team spirit!

involved have a lot time invested and little sleep. So, be understanding. Also, be aware that many of the attendants won't know what's going on and may see you in a bad light.

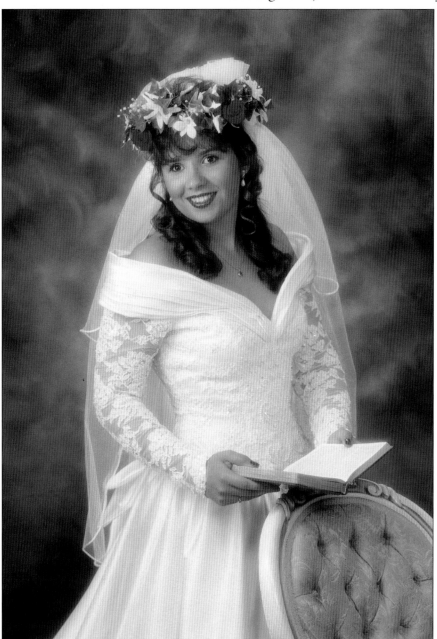

Define the bride's waistline by twisting the body at the waist and separating the arms from the body.

● MECHANICS

The Bride. Pose the bride as you normally would pose a woman, and make the dress and accessories work to your benefit, not against you. Accentuate long flowing graceful lines of the veil and train. Define the waistline by separating the arms and the body and by twisting the body at the waist. If holding a bouquet, position it in the hand farthest from your main light source and slightly above waist level for three-quarter and full-length portraits. With the other hand, try more formal, dance-like poses of the bride's hands by bending the hand away from the body at the wrist, showing the edge of the hand, and elongating the fingers. Turn the bride away from the main light source to maximize dress detail.

The Groom. Again, it is the unique clothing that will provide new posing opportunities. Suits and tuxedos are more restrictive to movement, but encourage straighter posture that invokes a feeling of positive attitude. Use this attitude to your advantage. You'll capture more dynamic images of the man, simply because he is more excited and more sure of himself as a subject.

The Bride and Groom. As opposed to most portrait sessions where you must build up the energy level, at a wedding, all you need to do is be ready for it to happen. You can guide the couple into poses that encourage their natural interaction. As with any couple, the combination of the bride in a graceful S-pose and the

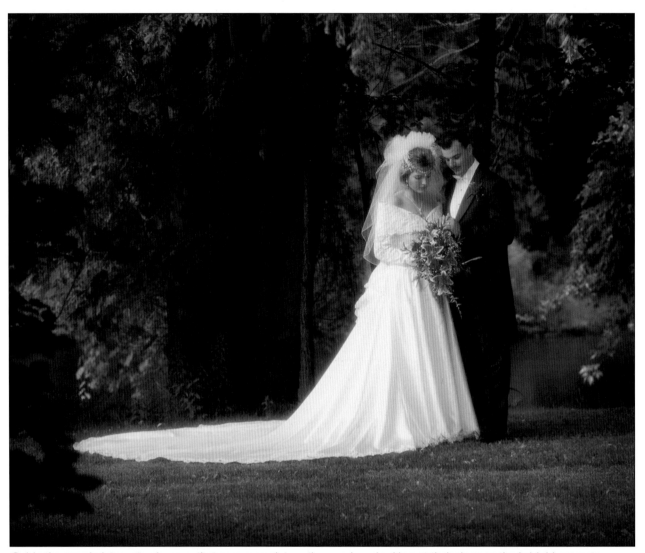

Guide the couple into natural poses that encourage interaction—such as looking at their rings or the bridal bouquet.

groom in the strong C-pose will add artistic value to the portrait. Just have them look at each other and hold each other, or have the bride look at her ring or flowers and have the groom look at her. At these points, their expressions will be genuine and full of love. If you get them involved with their parents, the wedding party, the miniature bride and groom, etc. and special moments will arise for you to record in wonderful portraits.

The Wedding Party, Families, etc. The number of people involved at a wedding can be astronomical. You can't expect all of them to feel well and be excited about having their portrait taken. Work quickly and efficiently, but still pay attention to detail. An assistant can be very helpful when posing

The number of people involved at a wedding can be astronomical.

groups. One of you can handle the camera and lighting while the other arranges the individuals and helps them pose. Order of importance and height are two major factors when arranging

When arranging group shots, place the most important individuals closest to the bride and groom.

groups at a wedding. Place the most important individuals closest to the bride and/or groom. Sort individuals and couples by height to assure that everyone is seen and has his own space and that the group is balanced as a whole. The bride and groom are obvious centers of interest and can serve as the focal point in a more interactive style portrait.

● KEY STRATEGIES

Establish a Link. Find someone besides the bride that knows many of the people and can be your direct connection for the day to the parties involved. It will save you time trying to find people while you should be focusing on your photography.

Build Up, and Break Down. Schedule your portraits of the bride and groom first and gradually build up to the largest groups (wedding party and families) as people arrive and then break back down to subgroups.

MODELS

● **PSYCHOLOGY**

Portraits vs. Portfolio Images. Model photography for advertising and for model portfolios and composites can vary greatly from traditional portraiture, but often they cross over and many professionals photograph both. The greatest difference is in purpose. The portrait is aimed to project the individual at her personal best for the individual and for family and friends. The model image is created to sell a product or to promote the individual's career as a model. Your poses will vary accordingly.

The Connection. Most powerful model images are the result of a connection between the model and photographer and their understanding of a common goal and the resulting level of confidence. Either via an agent, advertising agency, or directly, communication is a key. Ask the model what she feels are her strong and weak attributes and why. Since she is more analytical of her looks than the average person, she will definitely have an answer. Especially if she is an experienced profes-

Unlike portraits, portfolio images must be designed specifically to promote the model's career.

sional, ask her for her input. Posing is her business, too. Besides maximizing her potential, you may learn from her.

Models are in the posing business, too. Asking models—especially professionals—for their suggestions may result in better images and new ideas for other shoots.

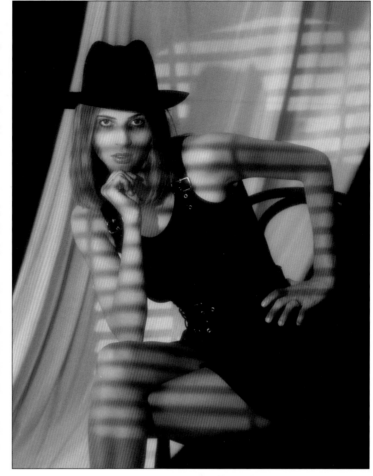

● MECHANICS

Variety. Whenever a model is assembling a portfolio or composite card, she should try to show a maximum number of different looks (ages, styles, trends, tight close-ups to full-lengths, expressions, moods, etc.). This will make her marketable to more modeling jobs. Your posing must accentuate these different looks.

Getting Extreme. While posing a model, you should pay close attention to details in her physical form and her clothing. Slight problems that may be acceptable in a portrait may be distracting in the model image. Also, your poses should be crisp and clean and taken one step farther than usual, more dramatic, graphic, and dynamic.

Above and Facing Page: Images for a model's portfolio need to be more dramatic and graphic than most portraits. Posing should be used in these images to help accentuate the different looks the model can achieve.

● KEY STRATEGY

Be Flexible. In the modeling/advertising world, there are a wide variety of personalities, likes, and dislikes. You won't be able to please them all, but do your best and learn from each experience. Don't be offended if a model goes to other photographers to build her portfolio. It is in her best interest to gather a variety of viewpoints and photographic styles. It is exciting to be able to work with a model over a period of time and be part of her growth and progress.

COUPLES

● **PSYCHOLOGY**

Harmony. The relationship between two individuals, human and/or animal, is almost musical when captured effectively in a portrait. Feelings of love, friendship, companionship, and support are most important in a couple portrait. Work to facilitate this interrelationship by being prepared and presenting a comfortable atmosphere and environment for them to be themselves.

● **MECHANICS**

S- and C-Poses. Use the classic S- and C-poses together to form an artistically pleasing wonderful portrait.

 Closeness. Use poses and posing tools that are complimentary and unobtrusive to allow the couple to position themselves together without interference. Steps or other objects positioned in a step-like fashion are helpful to build a "Bobsled" pose for a couple that is close, yet comfortable. With a man and woman, the man is positioned on the higher step with his feet apart on lower steps, and leaning forward. The woman sits between his feet and leans back toward him. This pose can yield

Step-like structures, such as the rocks shown here, often provide an excellent tool for posing couples.

everything from a close up to full-length poses in the classic S- and C- combination.

Levels. A guideline to use when posing a couple together is to set the eyes of one individual at the lip level of the other to form a dynamic diagonal line arrangement.

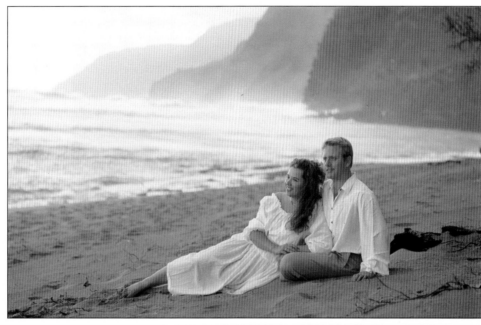

Right and Bottom Left: Portraits of couples should show their close relationship. **Bottom Right:** Setting one person's eyes at the lip level of their partner creates a strong diagonal line in the composition.

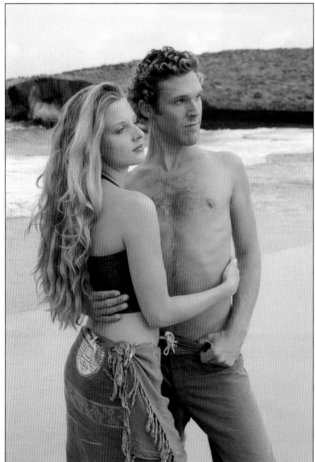

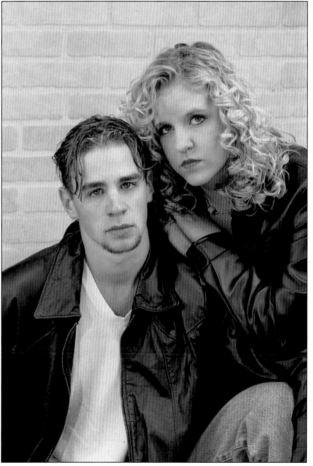

Depth. Depth of field control can be a surprising challenge with couples, especially for close up crops. Be careful to adjust their poses into the same focus plane, or separate them substantially, blurring one individual and focusing on the other.

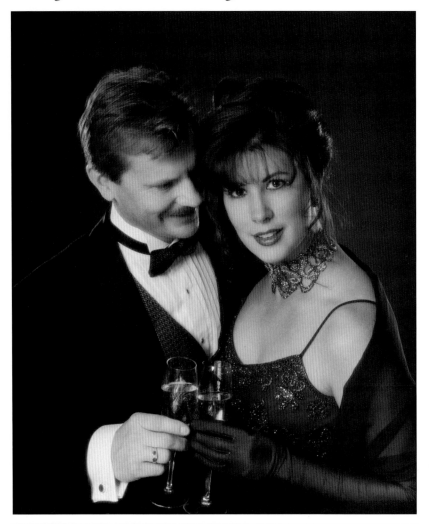

If the portrait is related to a special event, use it as a topic of conversation during the shoot.

● KEY STRATEGY

Share the Fun. Most couple portraits are friendship or event related: engagement, anniversary, school buddies, etc. Use these topics for conversation during the session. If you do, apprehensive subjects are more likely to relax and respond to your ideas and deliver more believable expressions.

FAMILIES

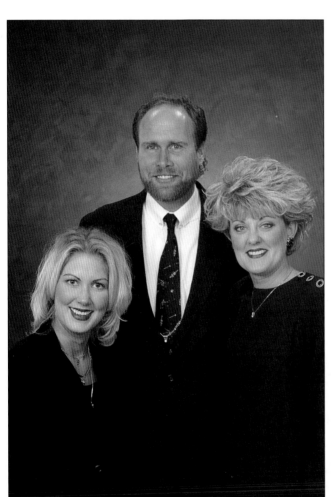

● PSYCHOLOGY

The Plan. As the numbers of individuals in a group increases, the challenge increases exponentially. More people=more personalities. Gather as much information from the group as you can and plan ahead. Know what they want and expect. Use your plan to gain and maintain control. Avoid periods of silence that will make the group nervous and open the possibility of interfamily discussion and conflict.

● MECHANICS

Center of Attention. Most family groupings center and/or raise to a peak the most important individuals and build outward from them to designate the family hierarchy.

Geometry. When arranging individual members of a family into a group, first visualize diagonal lines, triangles, and groups of triangles. If your end goal is a triangle, you won't get caught making static line-ups or totem poles. Second, pose each person properly within the triangles. Arrangement of family groups has often been compared to arranging a bouquet. The family "bouquet" must be balanced, with a foundation, and give each member his own space and identity.

Family Ties. Depending upon size restraints (size of the group and space available), you may choose either a tightly or loosely knit

This Page and Facing Page: When posing a group, begin by thinking in terms of lines (above, and facing page bottom) or triangles (right, and facing page top).

Facing Page: Don't forget to use the ground (or any other surface) to incorporate seated poses into your group composition.

grouping. The loose knit group provides room for subgroup identity. For example, individual families can be arranged into their own triangular groups, and then the various groups are brought together to form a family. The tight knit group is designed to spotlight the family as a whole, usually in the shape of a triangle (often referred to as a pyramid), or a group of triangles (a diamond or a series of triangular peaks). Members of the family may be bunched as subfamilies, but not necessarily.

Grounded. Don't forget to use the ground and build up a family grouping as you do each individual's pose. Sitting poses on the ground add variety to your poses and are helpful when hiding undesirable shoes, legs, etc.

Theme Portraits. A technique to build a unique interesting family portrait is to introduce and follow a theme, such as a picnicking, fishing, canoeing, washing the special car, etc. For example, the *Sound of Music* pose is popular for small families, where the family members hold hands and go for a walk down a lane. Although the group is more loosely posed, careful attention should be paid to make sure the individuals are in a position that is flattering to them when viewed from the camera angle. Theme portraits usually become lasting family heirlooms.

Focus. Similar to theme portraits, some family group portraits focus the primary attention of the group on a subject and not the camera (a baby, a pet, a piece of art, etc.).

● **KEY STRATEGY**
Professionalism. Be friendly, but in control. If you act in a professional manner, your clients will respect you and follow your directions closely.

24

Teams, Groups & Events

● **PSYCHOLOGY**

Short vs. Long Term. Although space and time constraints often do not allow for intricate posing when photographing large numbers of people in a short time, the quality of your posing will be an important factor in building repeat sales. Competition is tight in the team, group, and event portrait market. Your marketing, sales, and quality elements must be kept at the top level. If you don't, your clients will look elsewhere. If you do, you will build relationships that will be a true asset to your business.

Be Armed and Ready. In production type situations, where your time is limited, you must be organized and able to focus on your posing. If you have to worry about whether your lighting is working properly, your posing quality will suffer. If possible, arrange a contact person prior to the session to go to with questions and for help. Practice, practice, practice.

Variety. With time restrictions, you can't please everyone, but make an effort to not get locked in to a single pose. Sports package and prom photography are good examples. If you require every

Although competition in the team photography market is very tight, providing excellent posing can help boost client satisfaction and build repeat business.

team member or couple to pose in the exact same way for their individual or couple portrait, your images will be static and boring. This will discourage these clients from coming to you for other portraits in the future.

Above: Don't be afraid to try new poses and use unique posing structures. **Left:** You should try not to get locked into a certain pose, but sometimes you'll find a pose that just can't miss.

Depth Perception. When working with a large group, remember to keep the depth of the group as shallow as possible, use adequate depth of field from your exposure, and keep the group as close to parallel to the film plane as possible to maximize sharpness. Use posing tools that are compact and have a small footprint. Otherwise, you will have gaps that will be difficult to fill, because the posing tool is obstructing your arrangement opportunities. If you are working with bleachers or risers, pay attention to the strength and depth of each row. Some risers are so deep that they force you to have rows that are far apart and beyond your depth of field.

Couples. Posing couples at formal dances, proms, and events isn't always easy. Always start with solid posing techniques that flatter the subjects. Shift their weight to their back feet and from the ground up, tip their knees, hips, shoulders, and heads into graceful

When working with a large group, keep the depth of the group as shallow as possible and use adequate depth of field to ensure sharpness on each person.

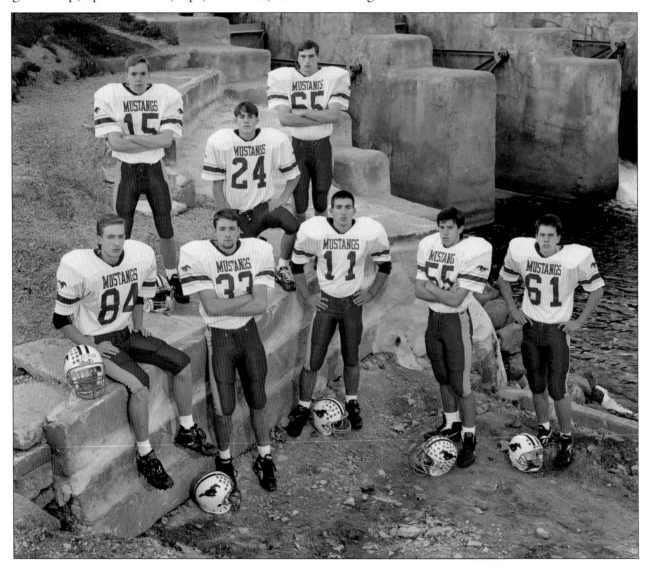

In production-type situations, where time is limited, be organized and able to focus on posing. If you have to worry about whether your lighting is working properly, your posing quality will suffer.

S-curve poses for the ladies and C-curves for the guys. Have a posing tool ready for women should they choose to sit, especially if they're taller than the men.

● KEY STRATEGY

Network. Establish and maintain relationships with key individuals in the schools, leagues, dance groups, etc. It will help you from both marketing and posing perspectives. Keeping clear and consistent communication with a coach, athletic director, instructor, etc. will facilitate the better posing opportunities mentioned earlier. Unfortunately, people change jobs often, and you'll need to make an effort to maintain effective contacts.

25

PETS

● **PSYCHOLOGY**

Think Like a . . . You don't have to show the pose to dogs or pot bellied pigs. But it helps to try to think like them and be considerate of their feelings. The studio closely resembles a veterinarian's office, and memories of slippery tables and needles. They get scared, bored, and overheated easily, so again it's best to work quickly. Speak to them with a calm reassuring voice.

● **MECHANICS**

The Basics. Just like humans, pose a pet from the ground (or gravity point) up. Be sure it is sitting, standing, or lying squarely. It is easy to let an animal position itself unevenly, which will lead to poor posture and unbalanced portraits.

Attention, Please. You can't tell most pets to turn their heads a certain way, but they will understand a special snack or squeaky toy. Don't call it by name; usually it will come running. Try various noises to get its attention, but be careful not to scare or irritate it. Short, distinct sounds work well.

After playtime, tired puppies can be quickly placed in a row for portraiture.

Know Your Subject. Take a minute to learn about the animal and study other portraits of that type of animal. Many animals are more than pets. It may be a show animal or breeding stock with specific confirmation standards that should be highlighted in its portrait posing.

Many animals are more than pets. As with people, learning about your animal subject is important to success.

Table the Motion. Use a table for smaller pets to help control their movement and provide a better vertical angle from which to photograph them.

The Lineup. Lineup posing should be avoided for most portraiture, but it can be very effective when positioning multiple pets. For example, puppies that are at the right age and have just completed their playtime may be placed quickly into a row. Often, their cute expressions and mannerisms are enough to distract from the normally static group pose.

> ● KEY STRATEGY
> *Teamwork.* Have an assistant who is comfortable with animals or the owner near the pet, repositioning or reassuring it if needed. This will help minimize your frustration and allow you to get the best images.

Facing Page: A special snack or sharp noise can help direct a pet's attention for proper head positioning. **Below:** For smaller pets, posing on a table will help control their movement and provide a better angle for photography.

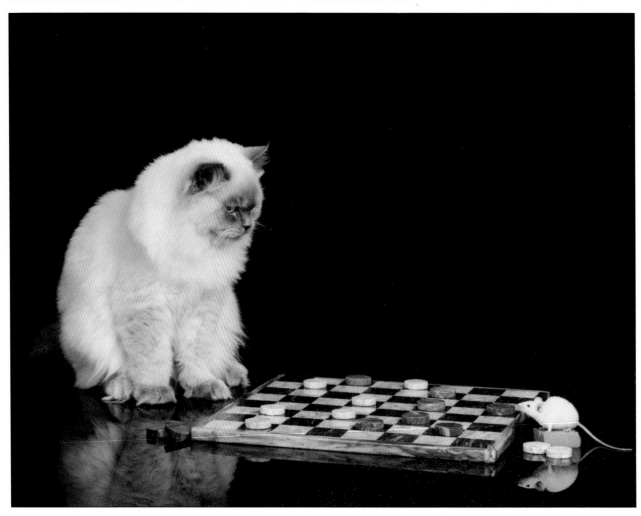

ABOUT THE AUTHOR

J.D. Wacker is the product of generations of professional photography. With his parents, Dave and Jean, and wife Sandra, he shares in the photography, digital imaging, and marketing responsibilities at their family studio, Photography by J.D., in Clintonville, Wisconsin.

He holds Masters Degrees in Photography and Electronic Imaging and the Craftsman Degree from the Professional Photographers of America, and is PPA Certified. Also, he holds a Bachelor's Degree in Business Administration, with an emphasis in marketing from the University of Wisconsin—Green Bay.

He has written several articles and manuals on portraiture, digital imaging, and marketing for major professional photography magazines including The Lens, InFoto, and The Professional Photographer. Together with his parents, he has lectured and presented seminars across the United States. His portrait work has been selected for many worldwide publications and displays, including *The Portrait*, published by the Eastman Kodak Company. In 1999, J.D. received the Kodak Gallery Elite Grand Award and the PPA Sports and Events Best of Show Award.

J.D.'s posing style is a mix of traditional and contemporary. He credits posing greats such as Gary Bernstien, Don Blair, Virgil Byng, Frank Cricchio, Hanson Fong, Yousuf Karsh, Mildred Totushek, and Monte Zucker as his primary sources. He credits his father, Dave, as his inspiration and guide toward being a better poser and portrait artist.

INDEX

PORTRAIT PHOTOGRAPHER'S HANDBOOK, 2nd Ed.

Bill Hurter

Bill Hurter has compiled a step-by-step guide to portraiture that easily leads the reader through all phases of portrait photography. This book will be an asset to experienced photographers and beginners alike. $29.95 list, 8½x11, 128p, 175 color photos, order no. 1708.

TRADITIONAL PHOTO-GRAPHIC EFFECTS WITH ADOBE® PHOTOSHOP®, 2nd Ed.

Michelle Perkins and Paul Grant

Use Photoshop to enhance your photos with handcoloring, vignettes, soft focus, and much more. Step-by-step instructions are included for each technique for easy learning. $29.95 list, 8½x11, 128p, 150 color images, order no. 1721.

LEGAL HANDBOOK FOR PHOTOGRAPHERS

Bert P. Krages, Esq.

This book offers examples that illustrate the *who, what, when, where* and *why* of problematic subject matter, putting photographers at ease to shoot without fear of liability. $19.95 list, 8½x11, 128p, 40 b&w photos, order no. 1726.

LIGHTING AND EXPOSURE TECHNIQUES FOR
OUTDOOR AND LOCATION PORTRAIT PHOTOGRAPHY

J. J. Allen

Meet the challenges of changing light and complex settings with techniques that help you achieve great images every time. $29.95 list, 8½x11, 128p, 150 color photos, order no. 1741.

THE ART AND BUSINESS OF
HIGH SCHOOL SENIOR PORTRAIT PHOTOGRAPHY

Ellie Vayo

Learn the techniques that have made Ellie Vayo's studio one of the most profitable senior portrait businesses in the U.S. $29.95 list, 8½x11, 128p, 100 color photos, order no. 1743.

PROFESSIONAL PHOTOGRAPHER'S GUIDE TO
SUCCESS IN PRINT COMPETITION

Patrick Rice

Learn from PPA and WPPI judges how you can improve your print presentations and increase your scores. $29.95 list, 8½x11, 128p, 100 color photos, index, order no. 1754.

PHOTOGRAPHER'S GUIDE TO
WEDDING ALBUM DESIGN AND SALES

Bob Coates

Enhance your income and creativity with these techniques from top wedding photographers. $29.95 list, 8½x11, 128p, 150 color photos, index, order no. 1757.

DIGITAL PHOTOGRAPHY FOR CHILDREN'S AND FAMILY PORTRAITURE

Kathleen Hawkins

Discover how digital photography can boost your sales, enhance your creativity, and improve your studio's workflow. $29.95 list, 8½x11, 128p, 130 color images, index, order no. 1770.

MASTER LIGHTING GUIDE

FOR PORTRAIT PHOTOGRAPHERS

Christopher Grey

Efficiently light executive and model portraits, high and low key images, and more. Master traditional lighting styles and use creative modifications that will maximize your results. $29.95 list, 8½x11, 128p, 300 color photos, index, order no. 1778.

LIGHTING TECHNIQUES FOR
LOW KEY PORTRAIT PHOTOGRAPHY

Norman Phillips

Learn to create the dark tones and dramatic lighting that typify this classic portrait style. $29.95 list, 8½x11, 128p, 100 color photos, index, order no. 1773.

THE BEST OF WEDDING PHOTOJOURNALISM

Bill Hurter

Learn how top professionals capture these fleeting moments of laughter, tears, and romance. Features images from over twenty renowned wedding photographers. $29.95 list, 8½x11, 128p, 150 color photos, index, order no. 1774.

THE DIGITAL DARKROOM GUIDE WITH ADOBE® PHOTOSHOP®

Maurice Hamilton

Bring the skills and control of the photographic darkroom to your desktop with this complete manual. $29.95 list, 8½x11, 128p, 140 color images, index, order no. 1775.

COLOR CORRECTION AND ENHANCEMENT WITH ADOBE® PHOTOSHOP®

Michelle Perkins

Master precision color correction and artistic color enhancement techniques for scanned and digital photos. $29.95 list, 8½x11, 128p, 300 color images, index, order no. 1776.

FANTASY PORTRAIT PHOTOGRAPHY

Kimarie Richardson

Learn how to create stunning portraits with fantasy themes—from fairies and angels, to 1940s glamour shots. Includes portrait ideas for infants through adults. $29.95 list, 8½x11, 128p, 60 color photos index, order no. 1777.

PLUG-INS FOR ADOBE® PHOTOSHOP®

A GUIDE FOR PHOTOGRAPHERS

Jack and Sue Drafahl

Supercharge your creativity and mastery over your photography with Photoshop and the tools outlined in this book. $29.95 list, 8½x11, 128p, 175 color photos, index, order no. 1781.

POWER MARKETING FOR WEDDING AND PORTRAIT PHOTOGRAPHERS

Mitche Graf

Set your business apart and create clients for life with this comprehensive guide to achieving your professional goals. $29.95 list, 8½x11, 128p, 100 color images, index, order no. 1788.

BEGINNER'S GUIDE TO ADOBE® PHOTOSHOP® ELEMENTS®

Michelle Perkins

Packed with easy lessons for improving virtually every aspect of your images—from color balance, to creative effects, and more. $29.95 list, 8½x11, 128p, 300 color images, index, order no. 1790.

BEGINNER'S GUIDE TO PHOTOGRAPHIC LIGHTING

Don Marr

Create high-impact photographs of any subject with Marr's simple techniques. From edgy and dynamic to subdued and natural, this book will show you how to get the myriad effects you're after. $29.95 list, 8½x11, 128p, 150 color photos, index, order no. 1785.

POSING FOR PORTRAIT PHOTOGRAPHY

A HEAD-TO-TOE GUIDE

Jeff Smith

Author Jeff Smith teaches surefire techniques for fine-tuning every aspect of the pose for the most flattering results. $29.95 list, 8½x11, 128p, 150 color photos, index, order no. 1786.

PROFESSIONAL MODEL PORTFOLIOS

A STEP-BY-STEP GUIDE FOR PHOTOGRAPHERS

Billy Pegram

Learn how to create dazzling portfolios that will get your clients noticed—and hired! $29.95 list, 8½x11, 128p, 100 color images, index, order no. 1789.

THE PORTRAIT PHOTOGRAPHER'S
GUIDE TO POSING

Bill Hurter

Posing can make or break an image. Now you can get the posing tips and techniques that have propelled the finest portrait photographers in the industry to the top. $29.95 list, 8½x11, 128p, 200 color photos, index, order no. 1779.

PROFESSIONAL DIGITAL IMAGING FOR WEDDING AND PORTRAIT PHOTOGRAPHERS

Patrick Rice

Build your business and enhance your creativity with practical strategies for making digital work for you. $29.95 list, 8½x11, 128p, 200 color photos, index, order no. 1780.

STUDIO LIGHTING

A PRIMER FOR PHOTOGRAPHERS

Lou Jacobs Jr.

Get started in studio lighting. Jacobs outlines equipment needs, terminology, lighting setups and much more, showing you how to create top-notch portraits and still lifes. $29.95 list, 8½x11, 128p, 190 color photos index, order no. 1787.

DIGITAL INFRARED PHOTOGRAPHY

Patrick Rice

The dramatic look of infrared photography has long made it popular—but with digital it's actually *easy* too! Add digital IR to your repertoire with this comprehensive book. $29.95 list, 8½x11, 128p, 100 b&w and color photos, index, order no. 1792.

THE BEST OF DIGITAL WEDDING PHOTOGRAPHY

Bill Hurter

Explore the groundbreaking images and techniques that are shaping the future of wedding photography. Includes dazzling photos from over 35 top photographers. $29.95 list, 8½x11, 128p, 175 color photos, index, order no. 1793.

LIGHTING TECHNIQUES FOR

FASHION AND GLAMOUR PHOTOGRAPHY

Stephen A. Dantzig, PsyD.

In fashion and glamour photography, light is the key to producing images with impact. With these techniques, you'll be primed for success! $29.95 list, 8½x11, 128p, over 200 color images, index, order no. 1795.

WEDDING AND PORTRAIT PHOTOGRAPHERS' LEGAL HANDBOOK

N. Phillips and C. Nudo, Esq.

Don't leave yourself exposed! Sample forms and practical discussions help you protect yourself and your business. $29.95 list, 8½x11, 128p, 25 sample forms, index, order no. 1796.

PROFITABLE PORTRAITS

THE PHOTOGRAPHER'S GUIDE TO CREATING PORTRAITS THAT SELL

Jeff Smith

Learn how to design images that are precisely tailored to your clients' tastes—portraits that will practically sell themselves! $29.95 list, 8½x11, 128p, 100 color photos, index, order no. 1797.

PROFESSIONAL TECHNIQUES FOR

BLACK & WHITE DIGITAL PHOTOGRAPHY

Patrick Rice

Digital makes it easier than ever to create black & white images. With these techniques, you'll learn to achieve dazzling results! $29.95 list, 8½x11, 128p, 100 color photos, index, order no. 1798.

The Practical Guide to Digital Imaging

Michelle Perkins

This book takes the mystery (and intimidation!) out of digital imaging. Short, simple lessons make it easy to master all the terms and techniques. $29.95 list, 8½x11, 128p, 150 color images, index, order no. 1799.

DIGITAL LANDSCAPE PHOTOGRAPHY STEP BY STEP

Michelle Perkins

Using a digital camera makes it fun to learn landscape photography. Short, easy lessons ensure rapid learning and success! $17.95 list, 9x9, 112p, 120 color images, index, order no. 1800.